Workshop of Phil Omodamwen

Benin City, March 26, 2022

Removal of looted artifacts, Benin, 1897

Enibokun Uzêbu-Imarhiagbe in the storage facility of the Museum der Kulturen Basel

Back of the relief plaque, inv. no. 10004 from the
Völkerkundemuseum der Universität Zürich with inv. no. BP5
from the collector Han Coray

Mobilizing
Benin Heritage
in Swiss Museums

Edited by Esther Tisa Francini, Alice Hertzog,
Alexis Malefakis, and Michaela Oberhofer

Scheidegger & Spiess

BIS
Benin
Initiative
Switzerland

Museum der Kulturen Basel
Bernisches Historisches Museum
Museum Schloss Burgdorf
Musée d'ethnographie de Genève
Musée d'ethnographie de Neuchâtel
Kulturmuseum St. Gallen
Museum Rietberg, Zurich
Völkerkundemuseum der Universität Zürich

Foreword and Acknowledgments

When we met for the first time in Zurich in March 2020, shortly before the Covid-19 pandemic, and launched the Benin Initiative Switzerland, it was not yet clear where this journey would take us. Our group of eight public museums all had in our collections objects from the Kingdom of Benin in Nigeria, but there were major gaps in our knowledge regarding their provenance. In view of the increasingly urgent debate about colonialism and restitution, the question arose as to which of the almost one hundred Benin objects we held had been plundered by the British Army in 1897 and had subsequently found their way into our museums via the international art market. It quickly became clear that we wanted to tackle the research collaboratively in order to create synergies at a national level and, above all, to integrate the knowledge and perspectives from the society of origin. The foundations for this were laid when the Federal Office of Culture approved our application for funding to support cultural heritage preservation in the area of provenance research. Following the initial phase of collaborative provenance research in 2021/22, the second phase in 2023/24 focused on exploring broader contexts such as slavery, reflecting on the methodology, and communicating our research findings in exhibitions and a discursive program of events.

Over the past four years, we have found new ways of working together—both analog and digital—across institutional boundaries and national borders. In the process, we have established a lively network that connects not only our eight museums but, most importantly, has brought us closer to our cooperation partners from Benin and the diaspora. Standout moments were the reciprocal visits in Nigeria and Switzerland, including trips to the Swiss museums' storage facilities, where, thanks to the intensive discussions that took place with the Nigerian experts, the objects—which had hitherto been just beautiful items in a museum—were suddenly filled with new life and a rich weave of stories. There was also the audience in the Royal Palace in Benin City, when we were able to present the Benin Initiative Switzerland to King Oba Ewuare II and the dignitaries present. In all of our meetings, the Nigerian side repeatedly emphasized their appreciation for the proactive approach and transparency of the Swiss joint project. This was also the case at the Benin Forum in February 2023, which marked another milestone with the announcement of the Joint Declaration. Together with a delegation from Nigeria, the eight Swiss museums reached an agreement on the future of the Benin collections and cooperation with Nigeria. Here, too, the mutual respect and positivity were tangible.

First and foremost, then, we would like to express our gratitude to our partners from Nigeria. Alongside Dr. Enibokun Uzébu-Imarhiagbe, who was responsible for the bulk of the research in Nigeria, there was also Prof. Kokunre Agbontaen-Eghafona, Chijioke McHardy Ani, Osaisonor Godfrey Ekhator-Obogie, Samson Ogiamien, Phil Omodamwen, Patrick Oronsaye, Prof. Abba Isa Tijani, Theophilus Umogbai, Dr. Charles Uwensuyi-Edosomwan, and most especially Prince Aghatise Erediauwa. Numerous colleagues from the eight museums, whom sadly we are unable to name here, have also contributed to the success of the Benin Initiative Switzerland. In their stead, we would like to take this opportunity to thank the directors for their support: Dr. Annette Bhagwati, Dr. Carine Ayélé Durand, Prof. Mareile Flitsch, Daniel Furter, Dr. Peter Fux, Dr. Yann Laville, Grégoire Mayor, Dr. Thomas Pauli-Gabi, and Dr. Anna Schmid. Our thanks also go to the Federal Office of Culture for its generous support, and in particular to Fabienne Baraga and the representatives of the Federal Department of Foreign Affairs in Nigeria. The Benin Forum and the publication were also supported by the Fondation Fridel et Witold Grünbaum pour la connaissance des cultures et des savoirs humains, the Swiss Society for African Studies, and the Swiss Academy of Humanities and Social Sciences, as well as by Dr. J. Plattner in memory of his wife Nelly Pajarola Plattner.

We are also extremely grateful to all the authors of this collection of essays for their multifaceted and stimulating contributions. The following people were responsible for the wonderful work on the images and text in this volume: Sandra Doeller, Thomas Kramer, and Mark Welzel, as well as Susanna Day Hamnett, Carolin Farbmacher, Claudia Kotte, Frank Süßdorf, Pascale Vacher, and Tradukas GbR—Simon Cowper, Melanie Newton, Lucy Powell, and Mark Willard—as translators and editors. And finally, we are deeply indebted to our core team of Africa curators and provenance researchers at the eight museums: Samuel B. Bachmann, Dr. Julien Glauser, Maylawi Herbas, Floriane Morin, Daniela Müller, Ursula Regehr, and Anja Soldat as well as all the others who have supported us on this journey, including Laura Falletta, Franziska Jenni, Peter Müller, Sarah Oechslin, and Achim Schäfer (†). It is gratifying to see how closely we have grown together and good to know that these bonds will lead to more collaborative projects in the future.

Alice Hertzog, Alexis Malefakis, Michaela Oberhofer, Esther Tisa Francini

1

Methods and Processes

8 Alice Hertzog, Alexis Malefakis,
Michaela Oberhofer, Esther Tisa Francini
Benin Initiative Switzerland:
New Ways of Working Together

16 Esther Tisa Francini
Milestones of the Benin Initiative
Switzerland 2020–2024

22 Benin Initiative Switzerland (BIS)
Joint Declaration of the Swiss
Benin Forum

26 Esther Tisa Francini, Alice Hertzog,
Daniela Müller, Enibokun Uzébu-Imarhiagbe
Collaborative Provenance Research:
Investigating Benin Object Biographies

32 Compiled by Josephine Ebiuwa Abbe
Ogbaisi, My King:
Songs of Lamentation in Honor
of Oba Ovonramwen

36 Daniela Müller and Michaela Oberhofer
Benin and the World:
Entangled (Art) Histories

40 Patrick Oronsaye and Alice Hertzog
"You Are Still Holding On To Our Future"

44 Voices

[Fig. 1] Map of museums in Switzerland that have Benin objects in their inventories

[Fig. 2] Participants in the Benin Forum at the Museum Rietberg

Alice Hertzog, Alexis Malefakis, Michaela Oberhofer, Esther Tisa Francini

Benin Initiative Switzerland

New Ways of Working Together

The focus of the Benin Initiative Switzerland (BIS) is on objects from the Kingdom of Benin in Nigeria that are held in eight public museums in Switzerland. The aim is to research the provenance of around 100 objects from Benin and to engage in dialogue about the history, significance, and future of the works. The initiative is the first Switzerland-wide collaborative project for researching the provenance of objects that were violently appropriated during the colonial era [Fig. 1]. The collaboration between the museums and representatives from Nigeria and the diaspora has encouraged the museums to take action, instigating the process of repatriating cultural heritage objects.

From the outside, museums often appear conservative and static. In recent years, however, a shift has taken place. And particularly in museums with non-European artifacts in their collections, there is a tangible sense of urgency in the air. The social environment of museums has changed radically since they were founded, often in the late nineteenth century at the height of colonialism. Today, digital technologies are accelerating this change and creating a broader public for museums to engage with. For some time now, sections of the global community have been calling on European museums to democratize cultural interpretations and allow the creators of the objects in their collections, or their descendants, to have a say in how their cultural heritage is seen and where it should be housed. Demands are being made for museum objects to be returned, especially if they were appropriated in contexts of colonial injustice and violence.

Fig. 3 The interior of the Royal Palace in Benin after its destruction in 1897, with Captain C. H. P. Carter, F. P. Hill, and unknown (from left)

These demands are no longer just coming from outside of the museums. Many of their employees also want to satisfy these requests and are looking for new ways of working together. This includes a critical examination of the collections' colonial past, transparency about the objects and collections in dealings with the source countries, and cooperation with representatives of the source communities.

Dealing with artifacts from the Kingdom of Benin is particularly urgent, because the violence and brutality with which the cultural heritage was plundered is well known and undisputed. The BIS is working with partners from Nigeria to prepare the ground for a dialog on the future of this cultural heritage [**Fig. 2**].

From the Palace into Exile

The objects from the Kingdom of Benin are currently at the center of the restitution debate and symbolize Africa's struggle to reclaim its cultural heritage.[1] From a Nigerian perspective, the objects represent the long history and elaborate art production of the Kingdom of Benin, which dates back to the first millennium CE. From the thirteenth century at the latest, artists were organized into hereditary guilds that created works of metal and ivory for the royal court.[2] These were elaborate relief plaques that adorned the columns of the palace or imposing memorial heads and ivory tusks that commemorated the ancestors on the palace altars. The objects embodied the cosmological, spiritual, and political beliefs of Edo society. They were never intended for sale and were to be used exclusively in a courtly context with the Oba's permission.[3] During the invasion and looting of 1897, the British wrested the objects from their local and cultural context.

In the course of the territorial expansion and economic exploitation of the African continent, the British founded the Niger Coast Protectorate in 1884 and, in 1892, imposed a so-called protectorate treaty on the Kingdom of Benin. Oba Ovonramwen, who had been in office since 1888 and regarded himself as a sovereign ruler, did not abide by the rules laid down by the British. In February 1897, the British colonial government responded by

1 Lagatz/Savoy/Sissis 2021.

2 The so-called Benin Bronzes are often made of brass and other metal alloys. The kingdom's material artifacts also include objects made of other materials such as ivory, terracotta, wood, and coral beads.

3 For more on the few exceptions to this, see the essay on the history of entanglement by Müller/Oberhofer, pp. 36–39.

sending in an armed force of 1,200 Royal Marines and 1,700 porters to Benin City [Fig. 3]. Oba Ovonramwen was stripped of his powers and sent into exile in the port city of Calabar, where he died in 1914 at the age of fifty-four. A fire destroyed large parts of the city. The British Army also plundered the royal palace and the homes of numerous dignitaries and shipped thousands of objects to Europe, where they remain in exile to this day.[4]

4 See, among others, Hicks 2020b; Phillips 2021; Plankensteiner 2022.

Circulation on the Art Market

As soon as the looted objects arrived in British ports in 1897, the works were sold on the art market on behalf of the Foreign Office, via fairs, auctions, and dealers. Merchants, colonial officials, and members of the military also disposed of the possessions they had looted or acquired in Nigeria, putting them on the market immediately after 1897 or selling them at a later date. Demand from German museums was particularly high, but museums in Great Britain and elsewhere also bought hundreds of objects from the raid.[5] The market for these little-known artifacts exploded.

The German museum anthropologist Felix von Luschan played an important role in evaluating the objects as works of art, publishing the first comprehensive monograph on the subject in 1919, which was widely read.[6] Demand from museums and private collectors soared. Exhibitions were organized—for example, the *Bronzes et Ivoires Royaux du Bénin* at the Musée d'Ethnographie in the Palais du Trocadéro, Paris, in 1932—which showcased the holdings of public and private collections, artists, bankers, industrialists, and wealthy art enthusiasts. As the objects circulated on the art market, they were transformed from booty into commodities and finally into museum artifacts behind glass.

5 The British Museum holds around 950 works from Benin; the University of Cambridge's Museum of Archaeology and Anthropology has 350. In Germany, the largest collections are in Berlin, which has over 500 objects from Benin, and Dresden, which has almost 300. These holdings are now the property of Nigeria; some are on permanent loan to German museums, while others are in Nigeria.
6 Luschan 1919.

As a result, from 1899 onwards, objects from the Kingdom of Benin also started to find their way into Swiss museums. Around a hundred works are in the holdings of public collections there, largely through the agency of the international art market. But Swiss trade representatives, scientists, entrepreneurs, missionaries, and mercenaries also profited from the colonial system, even though Switzerland itself had no colonies.

Fig. 4 *Die Kunst von Schwarz-Afrika* (The Art of Black Africa), exhibition, October 31, 1970 – January 17, 1971, Kunsthaus Zürich

Benin artifacts are still found in historical, ethnological, and art museums in Switzerland today. From the 1930s onwards, they were shown as works of art, particularly in special exhibitions at museums for art and the applied arts [**Fig. 4**]. Exhibition catalogs always included the story of Benin's defeat by the British, its violent colonization, and the looting that went with it.[7] In this respect, 1897 was not a taboo subject. While the objects were initially regarded as war trophies, artistic quality and iconography were prioritized later on. For a long time, the link to the military defeat provided cachet on the art market—in other words, a work's connection to the events of 1897 was seen as a guarantor, authenticating it as dating from the precolonial era. Today, however, the objects are no longer in circulation, at least not on the official art market. An awareness of the injustice that was done has become prevalent, and the traumatic events of 1897 and the circumstances surrounding them are being reassessed. It has taken more than 125 years to reach this point—both in Switzerland and elsewhere in the Global North.

The Way Back

In recent years, more and more museums, from Berlin to Cambridge and from Paris to Washington, have returned objects from their collections that were violently appropriated during the colonial era, restoring them to their countries of origin in Africa. There is even talk about a "decade of restitution."[8] This new dynamic was accelerated by the Black Lives Matter movement in 2014, by the criticism directed at the major Humboldt Forum project in Berlin, and by the 2018 report on the restitution of African cultural assets by Felwine Sarr and Bénédicte Savoy commissioned by French President Emmanuel Macron. Since then, more and more communities and countries in Africa have been reclaiming their cultural heritage. Benin is at the center of the debate because almost all museums worldwide—including in Switzerland—have holdings from the old Kingdom of Benin. The German government has done the most, transferring ownership of the more than 1,000 Benin artifacts held in German public museums to Nigeria in 2022.[9]

Reclaiming cultural heritage is nothing new, and in fact has a long history. But although Oba Akenzua II was able, in 1938, to recover the coral insignia of his father, who was deposed by the British, restitution claims had no success in the decades to follow. Even requests for loans from European museums were denied. A key moment in the restitution debate was the pan-African World Black and African Festival of Arts and Culture (FESTAC) in Nigeria 1977. The festival organizers wanted to borrow an ivory mask of the Queen Mother Idia that had been looted by the British, but the British Museum refused [**Fig. 5**]. As the logo of FESTAC '77, the image of this pendant mask still stands for the struggle for Africa's cultural heritage and the radicalized opposition to (post)colonial dependencies.

Museums in Movement

With the founding of the BIS, all eight Swiss museums agreed to expose the violent history of colonialism and acknowledge the colonial injustice inflicted on the Kingdom of Benin by the British Army in 1897. The cooperation with partners in museums, universities, the Royal Palace, and the art scene have allowed us to learn from the Nigerian perspective [**Fig. 6**].

The results of the research were published in the report "Collaborative Provenance Research in Swiss Public Collections from the Kingdom of Benin."[10] To facilitate the process of making decisions about the future of the collections, the report categorized the objects into four groups: 1) Objects looted in 1897; 2) Objects likely to have been looted in 1897; 3) Objects unlikely to have been looted in 1897; and 4) Objects not looted in 1897. The four categories constitute a spectrum ranging from objects that were most

7 See, for example, the exhibition catalogs including Benin art for shows in Switzerland: Kunstgewerbemuseum der Stadt Zürich, 1945; Kunsthalle Bern, 1954; Kunsthalle Basel, 1962; Kunsthaus Zürich, 1970 and 1984.

8 See Hicks 2020b; Lagatz/Savoy/Sissis 2021; Bodenstein 2022.

9 While the Nigerian side welcomes the restitution, the African American Restitution Study Group have leveled the criticism that descendants of enslaved people in America also have a right to their cultural heritage.

Fig. 5 Poster for the Second World Black and African Festival of Arts and Culture (FESTAC), January 15 – February 12, 1977, in Lagos and Kaduna, Nigeria

10 For information on the Benin Initiative Switzerland, see https://rietberg.ch/en/research/the-swiss-benin-initiative (accessed Apr. 9, 2024).

[Fig. 6] Phil Omodamwen and Enibokun Uzébu-Imarhiagbe

definitely taken from the palace during the military attack to pieces produced as tourist art in the late twentieth century. The categories also introduce a measure of uncertainty: for objects in categories 1 and 4, there are reliable sources and clear evidence that support this claim. In categories 2 and 3, despite the lack of written documents or established provenance data, there is nonetheless reason to suppose that the object is likely or unlikely to have been part of the 1897 loot. The categorization of the objects is dynamic and as new findings come to light, individual pieces have been reassigned.[11] It serves as a decision-making tool and has enabled museums and partners in Nigeria to focus on categories 1 and 2 in ongoing discussions on restitution [Fig. 7].

11 Müller 2024.

The research results have enabled participating museums to communicate clearly to Nigerian partners—be they from the government, the palace, the museum sector, or academia—and inform them of the objects they hold in connection with the 1897 looting. In 2023, the BIS welcomed a delegation of Nigerian actors to Switzerland to discuss the future of the collections.[12] Together, thirty Swiss and Nigerian stakeholders, including museum directors, palace members, curators, diplomats, guild members, artists, and cultural heritage professionals coauthored the "Joint Declaration of the

12 For footage from the Benin Forum, see: https://vimeo.com/886438853.

SNAKE'S HEAD, UHUNMUN EYEN/IKPIN Fig. 7

| Royal Guild of Bronze Casters Igun-Eronmwon
Nigeria, Kingdom of Benin
17th/18th century | Brass and metal nails
17 × 31 × 43 cm | Museum der Kulturen Basel
Inv. no. III 1036
Acquired in 1899 |

- 17th/18th century: Made by the Royal Guild of Bronze Casters
- Before 1897: Estate of Oba Ovonramwen Nogbaisi (ca. 1857-1914), Benin
- 1897: Looted by the British Army, Benin
[...]
- 1899: J. C. Stevens Auction Rooms (London)
- 1899: Acquired by William D. Webster (reg. no. 7573)
- 1899: Acquired by Museum der Kulturen Basel

Swiss Benin Forum." In this declaration, all participants agreed upon a transfer of ownership of the objects that were looted or likely to have been looted, which could involve their repatriation, circulation, or loan to Swiss museums.[13]

13 See the "Joint Declaration" on pp. 22–25.

In a series of exhibitions and events in 2024 and 2025, the participating museums will communicate the research results and ensuing political processes to the general public in Switzerland. In Zurich, both the Museum Rietberg and the Völkerkundemuseum are realizing exhibitions with Nigerian partners, reflecting upon the past, present, and future of their Benin holdings. The museums in Neuchâtel and Geneva are showcasing collaborations with Nigerian artists, and an intervention entitled "In Full View" addresses the Benin collections in Basel.

The Concept behind the Book

This publication has three entry points. The first section provides an overview of the methods and process of the BIS, the complex history of Benin, and the country's cultural heritage with a focus on Nigerian perspectives.

The second section delves into the provenance of the Benin objects and their tangled histories. It presents specific objects from each museum, showcasing research results from the BIS and illustrating case studies from the established categories. Object biographies illustrate the artifacts' trajectories from Benin to the vitrines or storage facilities of Swiss museums and provide contextual information on the people involved, the events that happened, and the circumstances of acquisition.

The final section presents various collaborations that have emerged from the BIS: these range from commissioning Nigerian contemporary artists, visualizing provenance data, and questioning colonial history to participative research projects with Swiss Edo diasporas and co-curating with Nigerian scholars and designers. These collaborations offer insights into some of the conversations currently underway between Nigeria and Switzerland, as museums seek to sustain the relationships developed over the course of the BIS.

Key to these various collaborations is an honoring of the Joint Declaration of the Swiss Benin Forum on the transfer of ownership of objects looted and likely to have been looted in 1897. The legal groundwork for returns is to be laid by the respective governing bodies of the different museums. This lays out a vision for the future, one in which museums in Switzerland move from being the owners of colonial collections to becoming custodians and facilitators, enabling social justice through repatriation and rebuilding trust with communities who no longer just want to be collected.

Milestones of the Benin Initiative Switzerland 2020–2024

2020

MARCH:
FOUNDING OF THE BENIN INITIATIVE SWITZERLAND (BIS)

Shortly before the first Covid-19 lockdown, there is a meeting at the Museum Rietberg between provenance researchers and the Africa curators from the eight Swiss museums holding collections from the Kingdom of Benin. They introduce each other to the Benin objects in their respective museums, discuss current scholarly and political issues, and decide to establish a network that will enable them to reappraise the history, provenance, and current significance of their Benin collections.

NOVEMBER 15:
FINANCING BY THE SWISS FEDERAL OFFICE OF CULTURE

With the Museum Rietberg at the helm, the eight participating museums apply to the Swiss Federal Office of Culture for financial support. Since 2016, the Federal Office of Culture has provided funding for investigating and publishing artworks with a special focus on art stolen by the Nazis. It is the first-ever application for a joint project relating to colonialism's violent past. Funding is approved at the end of the year.

2021

APRIL:
COOPERATIVE PROVENANCE RESEARCH AS A NEW APPROACH

From the very beginning, provenance research is envisioned as a collaboration between Nigeria and Switzerland with a Nigerian historian working together with a Swiss anthropologist. Historian Enibokun Uzébu-Imarhiagbe from the University of Benin is tasked with conducting research in Nigeria and Switzerland. Anthropologist Alice Hertzog takes up the position of provenance researcher acting for the eight museums in Switzerland. She is based at the Museum Rietberg.

SEPTEMBER:
VISIT TO SWITZERLAND

After participating in several online workshops, Uzébu-Imarhiagbe travels to Switzerland. She visits the museums participating in the BIS and gets together with the curators to discuss the significance, materiality, and dating of the works. A joint workshop is held to clarify the next steps, determine areas of research, and decide on interview partners in Nigeria.

Fig. 1 Meeting at the Museum Rietberg, Zurich, September 6, 2021
Fig. 2 Working with the Benin objects in the Museum Rietberg, Zurich, August 30, 2021

NOVEMBER:
THE RESEARCH NETWORK

After a phase of intensive documentation and research work in all of the BIS museums, Hertzog makes a research trip to Paris and London, where she visits the archives and conducts interviews with experts. She establishes a research network and is able to flesh out the provenances of a number of objects, determine the names (previously unidentified) of collectors and dealers, and fill in the gaps in the object biographies. Uzébu-Imarhiagbe conducts interviews with experts and with members of Benin's royal palace and Benin City's guilds.

2022

**MARCH:
VISIT TO NIGERIA**

Alice Hertzog and Michaela Oberhofer travel to Lagos and Benin City with the aim of expanding the BIS network in Nigeria and to speak with artists, scholars, and museum representatives. Uzébu-Imarhiagbe organizes a workshop at the University of Benin focused on research and dialogue with around thirty individuals from academia, museums, the Benin's royal palace, and the arts. They express great interest in further collaboration. The researchers are invited to an impromptu audience at the royal palace in Benin, during which they inform Oba Ewuare II about the BIS's work.

Fig. 3 The BIS delegation visiting the National Museum in Lagos: (from left to right) Babatune E. Adebiyi (legal adviser), Thomas Schneider (Swiss Consul General), Michaela Oberhofer (MRZ), Abba Tijani (Director General, NCMM), Enibokun Uzébu-Imarhiagbe (University of Benin), Alice Hertzog (BIS), and Adeboye Omotaye (curator, National Museum, Lagos), March 21, 2022

Fig. 4 Workshop participants at the University of Benin, March 25, 2022
Fig. 5 An audience with the Oba: Michaela Oberhofer introducing the BIS, March 25, 2022
Fig. 6 Michael Ehaniroe in discussion with Enibokun Uzébu-Imarhiagbe, March 26, 2022

SUMMER:
THE RESEARCH REPORT

The objects are assigned to four categories for the purposes of the report on the first phase of the BIS: Looted; Likely to have been looted; Unlikely to have been looted; Not looted. Three case studies provide insight into the provenance researchers' methods. The 120-page report also contains a comprehensive bibliography as well as information about the network and the databases and auction catalogues researchers used.

FALL:
TRANSPARENCY

Documentation of the objects examined by the BIS and previous research findings are made available on the "Digital Benin" online platform, where they can now be accessed from all over the world. The Museum Rietberg's website also contains valuable information about the BIS. The BIS's member museums also publish the most important data relating to the project as well as their own collections.

NOVEMBER:
COMMUNICATION AND METHODOLOGY

The BIS applies for funding to support a second phase emphasizing unanswered questions relating to provenance, the issue of education and communication, and further cooperation with Nigeria and representatives of the diaspora. Equally important, however, is the focus on additional contexts involving object histories as well as the trade in enslaved individuals between the Kingdom of Benin, Europe, and Switzerland. At the same time, consideration is to be given to the methods applied and to new curatorial concepts of education. The Federal Office of Culture approves the project's continuation.

2023

LATE JANUARY, EARLY FEBRUARY:
THE SWISS BENIN FORUM

A public event is held in the Museum Rietberg for the Swiss Benin Forum, during which the BIS report is submitted to representatives of Benin's royal family and the state museums. The joint declaration is also read aloud. Members of the panel speak about the objects' significance, cooperative projects, and new ties between Switzerland and Nigeria.

Fig. 7 Examining objects in the storage facility of the Museum der Kulturen Basel, January 31, 2023

FEBRUARY 2:
THE JOINT DECLARATION

A ten-member delegation from Nigeria arrives in Switzerland to attend the Swiss Benin Forum. The delegation consists of representatives of the artist guilds, the university, the state museums, and the royal family. At the Museum der Kulturen in Basel, a joint declaration titled "Addressing the Future of the Benin Collection in Swiss Museums" is adopted. One of its fourteen points addresses the issue of the restitution of looted objects and those that are likely to have been looted.

Fig. 10 Podium discussion during the Swiss Benin Forum at the Museum Rietberg, Zurich, February 2, 2023

Fig. 8 Group photo in the courtyard of the Museum der Kulturen Basel, January 31, 2023
Fig. 9 Submission of the BIS report from Phase I during the Swiss Benin Forum at the Museum Rietberg, Zurich, February 2, 2023

MAY:
NEW AREAS OF FOCUS

Daniela Müller takes up the position of provenance researcher for the second phase of the project. She focuses on expanded historical contexts—including the issue of the transatlantic trade in enslaved people between Benin and Europe—open questions relating to provenance, how these are put across in exhibitions, lectures, and workshops, and an evaluation of the methods developed over the course of the project.

SUMMER / FALL:
PROVENANCE RESEARCH CONTINUES

Archival research conducted in Berlin reveals information about Felix von Luschan and follows the tracks of duplicate objects that were sold by art dealers after the period of German colonial rule as museums sought to reassess their collections. Later that year, Müller conducts additional research in London and examines auction catalogues. For the first time, the idea of a joint publication is discussed.

2024

JANUARY 25: ADDITIONAL RESEARCH AND COMMUNICATION

The team meets at the Musée d'ethnographie de Neuchâtel. The end of the second phase of the project sponsored by the Federal Office of Culture is approaching, and the main focus is the communication of the project results. The team defines its program for 2024 with a look ahead to 2025 and specifies the publication that is due to be published by Scheidegger & Spiess and made available online after the project is completed.

Fig. 11 Curators and provenance researchers from the BIS at the Musée d'ethnographie de Neuchâtel, January 25, 2024

FEBRUARY 27: LOOKING BACK ON THE METHODOLOGY

At another meeting, the project team evaluates the methods used in the cooperative project and reflects on the BIS's findings. The focus is on the model set up for the project and how this can be applied to similar research projects in the future. Together with the connections made to Nigeria, the close ties between the Africa curators and the provenance researchers that were established and enriched at the institutions over the course of the project look promising for a new form of museum work.

SPRING / SUMMER: EXHIBITIONS AND PROSPECTS FOR THE FUTURE

Exhibitions showing works from the Kingdom of Benin are opened in Neuchâtel, Geneva, and Zurich. Not only is the collaborative curatorial work made apparent to visitors but new narratives and a completely new way of looking at the objects is made possible by focusing on their violent appropriation from the royal family and examining the role of art dealers and the objects' original significance. In recent years, new networks and ties between Swiss museums and Nigeria have been established offering a solid basis for future collaborative projects.

Joint Declaration of the Swiss Benin Forum

Addressing the Future of the Benin Collections
in Swiss Public Museums

February 2, 2023

Joint Declaration of the Swiss Benin Forum

We, the participating museums of the Benin Initiative Switzerland (BIS), the representatives of His Royal Majesty the Oba of Benin, the Director General of the National Commission for Museums and Monuments of Nigeria, the representative of the Nigerian Embassy to Switzerland, along with Nigerian researchers and artists, have wholeheartedly reached the following agreement on the Benin objects currently in Swiss public museums:

1. The ownership of the objects which were looted or likely to have been looted in 1897 should return to the original owner.

2. The participating museums are open to a transfer of ownership of these objects, which could involve repatriation, circulation, or loans to Swiss museums.

3. The Benin objects are items of social, religious, historical, and aesthetic importance with emotional value.

4. The Benin objects carry histories that need to be told, and the public should be informed as to how and why the objects came to be in Swiss museums.

5. The Benin objects can be ambassadors that draw admiration and understanding, show beauty and skills, and enhance respect.

6. The Benin objects shall serve as education for school and university students, artists, and society in general.

7. The BIS can set an important example for dealing with colonial heritage.

The BIS will pursue its collaborations on the basis of the values and commitments presented below:

Joint Declaration of the Swiss Benin Forum

On the Future of Our Collaborations

8. The BIS commits to developing new models of exemplary collaboration that foster sincerity and transparency and restore dignity. These relationships are foreseen as long-term, open engagements that respect the plurality of world views involved and adopt a new relational ethics.

9. As a hub, the BIS will seek to enable multilevel initiatives. This network will connect people with one another and engage communities of origin, the Swiss and Nigerian general public, and the diaspora.

10. The artists, guilds, and artisans of Benin should be encouraged and enabled, in order that the artistic production of Benin remains alive.

11. We will contribute to the interflow of knowledge, developing joint exhibitions, research, and exchanges with museums, universities, and art schools.

12. We will explore our entangled and shared histories along with the provenance and circulation of objects, shedding light on museum histories in Nigeria and Switzerland.

13. We will collaborate to improve our shared research on the care, conservation, and display of Benin's heritage. This will enliven objects with renewed interpretation and recognize their value and cultural significance in a way that can be of benefit to the people of Nigeria and Switzerland.

14. As we develop our future collaborations, making new history together, we recognize that the objects are an expression of Beninese identity and the Benin people's reverence for the Oba of Benin.

Joint Declaration of the Swiss Benin Forum

Authored by:

Prof. Abba Isa Tijani, Director General, NCMM

Theophilus Umogbai, Head of Research, Planning, and Publications, NCMM

His Royal Highness Prince Aghatise Erediauwa on behalf of his Majesty the Oba of Benin

Dr. Charles Uwensuyi-Edosomwan, Chief Obasuyi of Benin, Senior Advocate of Nigeria

Chijioke McHardy Ani, Minister Counsellor, Embassy of Nigeria, Bern

Samuel Bachmann, Africa Curator, Bernisches Historisches Museum

Dr. Carine Ayélé Durand, Director, Musée d'ethnographie de Genève

Dr. Annette Bhagwati, Director, Museum Rietberg, Zurich

Prof. Kokunre Eghafona, Professor of Cultural Anthropology, University of Benin

Osaisonor Godfrey Ekhator Obogie, Historian and Researcher, Benin Studies Institute

Prof. Mareile Flitsch, Director, Völkerkundemuseum der Universität Zürich

Daniel Furter, Director, Museum Schloss Burgdorf

Dr. Peter Fux, Director, Kulturmuseum St. Gallen

Dr. Julien Glauser, Africa Curator, Musée d'Ethnographie de la Ville de Neuchâtel

Dr. Alice Hertzog, Anthropologist and BIS Researcher, Museum Rietberg, Zurich

Dr. Yann Laville, Co-director, Musée d'Ethnographie de la Ville de Neuchâtel

Dr. Alexis Malefakis, Africa Curator, Völkerkundemuseum der Universität Zürich

Grégoire Mayor, Co-director, Musée d'Ethnographie de la Ville de Neuchâtel

Floriane Morin, Africa Curator, Musée d'Ethnographie de Genève

Dr. Michaela Oberhofer, Curator for Africa, Co-head BIS, Museum Rietberg, Zurich

Samson Ogiamien, Visual Artist and Artistic Director of the Edo Cultural Art Forum

Phil Omodamwen, 6th Generation Bronze Caster, Benin City

Patrick Oronsaye, Art Historian, Member of Ekaiwe Royal Society

Dr. Thomas Pauli-Gabi, Director, Bernisches Historisches Museum

Ursula Regehr, Africa Curator, Museum der Kulturen Basel

Dr. Anna Schmid, Director, Museum der Kulturen Basel

Anja Soldat, Curator of Cultural Anthropology, Kulturmuseum St. Gallen

Esther Tisa Francini, Head of Provenance Research, Co-head BIS, Museum Rietberg, Zurich

Dr. Enibokun Uzébu-Imarhiagbe, Historian and BIS Researcher, University of Benin

[Fig. 1] Patrick Oronsaye and Enibokun Uzébu-Imarhiagbe in Benin City

[Fig. 2] Esther Tisa Francini in the Kunsthaus Zürich archives

[Fig. 3] Alice Hertzog discussing the project's findings at the Museum Rietberg

Collaborative Provenance Research

Investigating Benin Object Biographies

Provenance research serves to reconstruct object biographies. Specifically, it seeks to identify collections acquired in unjust contexts. It employs methods from different disciplines like history, anthropology, conservation/restoration, and art history to trace the biographies of objects, reveal their complex and often ambiguous histories, and lay the foundation for solutions in the future, including restitution. It was developed and established following the adoption of the Washington Principles in 1998 and was initially used to identify property stolen by the Nazis.[1] Since the late 2010s, it has been further developed to investigate collections from colonial contexts, based on the ethical guidelines of the International Council of Museums (ICOM) and recently developed manuals.[2]

Information is frequently lost during the transfer and transformation of objects, and it is common to see missing documentation, gaps in object biographies, and uncertainties about their precise designation. One solution is to collaboratively co-produce knowledge with the countries of origin and the affected communities, applying an oral history approach focused on local historiographical traditions [**Fig. 1**]. Collaborative provenance research not only serves to identify past owners and how objects arrived in museums but also produces joint understandings about the objects: What significance do they have for Beninese people today? What was their function before 1897? What happened to the objects after they were looted? And who do the objects belong to today?

[1] The Washington Conference Principles on Nazi-Confiscated Art, released on December 3, 1998: forty-four countries agreed at the Washington Conference on Holocaust-Era Assets to eleven principles that seek "just and fair" solutions, presenting an ongoing challenge to museums, archives, and libraries.

[2] Förster et al. 2018; DMB 2021; VMS 2022. ICOM's ethical guidelines were first adopted in 1986—they are currently being revised to adapt them to the museum definition adopted in 2022, where the focus is on participation, diversity, and community cooperation.

Collaborative Undertakings

The provenance research undertaken in the context of the Benin Initiative Switzerland (BIS) is collaborative on various levels. In the first instance, it has seen the Africa curators and provenance researchers of eight Swiss museums working together with each other to further their understanding of the Benin collections. This collaboration was also pragmatic, given the overlaps in the collections, the dealers involved in the acquisitions, and the particular archives investigated.

The partners in Nigeria—who number academics, palace representatives, guild members, and museum professionals—brought in their specific knowledge and perspectives. This has enabled the project to embed Nigerian and Beninese insights and understandings of the objects, complementing, and at times countering, narratives found in European archives and in Swiss museums [Figs. 2, 3].

Absence and Presence in the Sources

There is a vast body of literature on the Kingdom of Benin authored by scholars both from Nigeria and from the Global North.[3] But only in recent years, with the emergence of provenance research and restitution claims, has greater attention been paid to the art trade, exhibition histories, collectors, and dealers.[4] Previously there had been no study of Benin collections in Switzerland, a knowledge gap that the BIS has now filled.

The starting point for provenance research is the objects themselves, which often contain traces of their past, be it on the back or underside, where there may be signs of use, numbers, customs stamps, adhesives, or evidence of restoration.[5] These traces need to be supplemented by museum archives and other written sources, expert knowledge, and oral history [Figs. 4, 5, 6]. The research on families and genealogies provides an extended biographical context for the actors involved that affords a better understanding of the objects' trajectories. Access to information and sources worldwide is increasingly facilitated through digitization efforts. The Digital Benin database, for example, which has been online since autumn 2023, shows the fragmentation of the former palace inventory as a dispersed archive.[6] It provides a clear overview of the circulation of the objects and the paths they took, which in turn opens up avenues for research.

Despite the analysis of extensive material, many gaps in the individual object biographies and questions about the sale of looted war booty remain unanswered. Notwithstanding recent studies on the sale of the objects in auctions and fairs in London following the military raid in 1897, the private circulation of the objects involved and the lack of art market studies in the early twentieth century presented insuperable challenges. However, the research gave us a deeper understanding of the whereabouts of the war booty and of the absence in the archives, until now, of Nigerian voices in Swiss museums.

From Loot to Tourist Art

The categorization of the research results was based on how likely it was that the objects were looted in 1897 [Fig. 7]. For example, objects in the first category provided a stronger paper trail leading back to the looting and the immediate aftermath of 1897 [Fig. 8]. Some of them also present forensic traces of looting, such as burns from the fire that occurred during the attack. Objects in the second category present little written evidence but are representative of royal court art predating 1897. They must have been in the palace during the military attack and are therefore considered to be "Likely to have been looted." Objects in the third category, "Unlikely to have been

3 Plankensteiner 2007, 2022, including numerous contributions from Nigerian scholars; Lundén 2016; Hicks 2020b; Docherty 2021; Phillips 2021; for a Nigerian perspective on the history of Benin and the issue of restitution, see Layiwola 2010.

4 See, for example, Bedorf 2021; Hicks 2021; Lidchi 2021.

5 See object biographies, pp. 50–81.

6 See Digital Benin website, https://digitalbenin.org/.

[Fig. 4] The Nigerian delegation inspecting the objects held by the Musée d'ethnographie de Genève (MEG)

[Fig. 6] Staatsbibliothek Berlin, Stiftung Preussischer Kulturbesitz, estate of Felix von Luschan

[Fig. 5] Ernst Winizki's invoice for the sale of a carved ivory tusk to the Museum Rietberg

[Fig. 7] Categorization of Benin objects in the BIS museums

MKB = Museum der Kulturen Basel
BHM = Bernisches Historisches Museum
MSB = Museum Schloss Burgdorf
MEG = Musée d'ethnographie de Genève
MEN = Musée d'ethnographie de Neuchâtel
KMSG = Kulturmuseum St. Gallen
MRZ = Museum Rietberg, Zurich
VMZ = Völkerkundemuseum der Universität Zürich

■ Looted ■ Likely to have been looted ☐ Unlikely to have been looted ☐ Not looted

[Fig. 8] Catalogue of ethnological specimens by William D. Webster, vol. 29, London 1901, mentioning the origin of the works from the looting of Benin

looted," do not have a clear paper trail back to 1897, show evidence of having been translocated after 1897, or are not emblematic of Benin court art. They may have been produced after 1897. This is the most uncertain category. Finally, objects not looted in 1897 were produced during the twentieth century, the majority of them after independence.

The research results suggest that just over half of the objects were either looted (21) or likely to have been looted (32), with the remainder either unlikely to have been looted (16) or not looted (27). The categorization incorporates a measure of uncertainty and encompasses objects with reliable provenance sources—which enable us to confidently assert whether they were looted or not—and objects for which there is more uncertainty, with fewer sources and less evidence.[7] Despite the research, there remain gaps in the provenances. Nevertheless, there is a need for interpretation and for making the current state of knowledge productive.

7 See Hertzog/Uzébu-Imarhiagbe 2023.

Transparency and Dialogue

Swiss museums aimed to clearly communicate the results of their research to Nigerian partners. The findings were published in the fall of 2022 on the websites and in the online collection of the BIS museums and on Digital Benin, contributing to an online platform that connects the Benin objects of over 130 institutions and makes them available to a global audience.

In February 2023, Swiss museums handed over the first research report to a Nigerian delegation from the National Commission for Museums and Monuments (NCMM), members of the palace of the Oba of Benin, and representatives of the royal guilds and the University of Benin at the Benin Forum in Zurich. This represented a new milestone in the relationship with the original owners of the objects and formed the basis for the agreement to transfer the titles of looted objects back to Nigeria.

During the research process, these findings were communicated to the Swiss public on an ongoing basis through public talks, events, and other educational efforts undertaken by the museums involved, culminating in a series of collaborative exhibitions and events in the participating institutions in 2024 and 2025. The in-depth analysis of object biographies—also presented in this volume—with a focus on objects, peoples, and places, reveals the controversial history inscribed in the works. This contributes to ongoing discussions about Switzerland's involvement in colonialism.

Josephine Ebiuwa Abbe during a performance at Museum Rietberg

Compiled by Josephine Ebiuwa Abbe

Ogbaisi, My King:
Songs of Lamentation in Honor of Oba Ovonramwen

Lamentation Songs composed by: [1] Monday Edo Igbinidu [2] and [3] Edo Cultural Group
[4] Lady Aghabiomon Ogbeiwi

1 | Ogbaisi mwen nogie

Ogbaisi mwen nogie mwen o
Ogbaisi, my king,
Ovonramwen ekhara no guedo
Ovonramwen, who presides over Edo,
Ogbaisi mwen nogie mwen
Ogbaisi, my king,
Ovonramwen n'Ogbaisi mwen nogie
Ovonramwen, Ogbaisi, my king,
Ogbaisi o
Ogbaisi

2 | Ehi mwen

Ehi mwen oooo
My guardian angel,
Uma do sumwen o, ehi ooo
come to my aid, guardian angel

3 | Iye mwen niye

Iye mwen niye mwen o, yemwen o
My mother, my mother, my mother,
Ibie ogha ku khun ni kpa kpa
The insides should have been on the outside
Na ghi hen vbe khoe ye o
So as to know the intent of the heart.
E e iyemwen
My mother

4 E o yowo

E e e ooo yowooo,
Oh nooooo
Ebo ye hue hue
The white man deceitfully
Mu Oba Ovonramwen le ooo
Carried Oba Ovonramwen away.

Oghi ma ni ma ye oooo
We were on our own,
Eki ma ni ma do ooo
Minding our own business,
Oba mwan ni ma ga aaa
Serving our Oba,
Ugie-Oba mwan ni ma do ooo
Performing the festival of our Oba.

Ebo ni ve re eee
The white men came and
Mue san gien dan lai vbo oo
Brought bad blood to the land.
Ti hian do gbo gaga
They came to compete
Ye no gha ka mu'Edo oo
To be the first to capture Edo,
Edo mwen n'Oba ye
Edo, land of the Oba of Benin.

James Philipi nebo
James Phillips the white man,
No gbe ria khe ooo
The overzealous,
Oriaria gha di'Edo oo
Came to Edo
No do ruo ghi gue se
To overdo it.
Owi hion gha mu'Edo
He swore to capture Edo.
Eki gbe e, Ogbe re o
But he failed.
Ke vbe mwin ye ta ye ton ogh'Edo
He took many Edo artifacts
Ovio gha rievbuebo
To the white man's land.

Capt. Gen. Moor, no odion
Capt. Gen. Moor, the Elder,

Oka gbe be ri'Edo
Wrote a letter to Edo,

Kha m'Oba mwan
Telling the Oba,

Ede ra e mi ghi re
I will come in three days' time.

Vbo gha d'Ugie Ague fo ne
When he (Oba) is done with the Ague Festival,

Ihia ye London ni re o Oba
I am traveling back to London, Oba.

Ebo mwen lele oooo
The white men have laws,

Edo mwen vbe mwen lele
The Edo also have laws.

Oba gha d'Ugie Ague vb'Edo
When the Oba observes the Ague ceremony,

E te ghe re o
Strangers are not received

Ugha re awua oto no o no siuwu
Violation of this is a sacrilege that may result in death.

Ebo, Ugha re, awua oto no o no siuwu
White man, violation of this is a sacrilege that may result in death.

Jonathan Adagogo Green, postcard showing Oba Ovonramwen on board the yacht Ivy on his way into exile in Calabar, 1897

Benin and the World

Entangled (Art) Histories

The history of the Kingdom of Benin dates back to the first millennium and is deeply entangled with Europe and the rest of the world.[1] Early relations were based on lively economic, political, and cultural exchange. Even in the seventeenth century, European visitors such as Olfert Dapper were fascinated by the size, splendor, and architecture of Benin [Fig. 1]. It was not until the nineteenth century that the mood changed, and Benin would be indelibly associated with human sacrifice and cruelty. Such propaganda served to legitimize the colonial conquest of the kingdom. Benin's complex and entangled history with the world played out both economically and artistically.

Trade in Commodities and People

From the fifteenth century onwards, transatlantic commerce shifted the trade routes between West Africa and Europe from the Sahara to the coastal regions and the Atlantic. Despite its inland location in the forests of Guinea, Benin was connected via waterways to the Niger Delta and the sea. The Portuguese were the first important European trading partners but were replaced by the Dutch in the late sixteenth century and later by the French and British. Up until the land was conquered and turned into a colony at the end of the nineteenth century, the supreme ruler of the kingdom, the Oba, controlled trade with the Europeans. Luxury goods such as fine fabrics, coral pearls, copper and brass, and firearms were imported from Europe and Asia. Exports from Benin included Guinea pepper, ivory, redwood, beads (Cori), and fabrics handwoven from cotton and raffia; palm oil and rubber followed later.

1 In the thirteenth century, the kingdom was called Ubini. When Portuguese sailors reached the coast of Benin Bay in 1472, they turned this into "O Beny," which became Benin. Edo is the name given to the people of Benin and their language. For more on the history of Benin, see Egharevba 1936; Igbafe 1974; and Plankensteiner 2007.

Fig. 1 Olfert Dapper, view of the city of Benin from the book *Naukeurige Beschrijvinge der Afrikaensche Gewesten*, 1686

Like other large empires near the coast, Benin also benefited from the emerging trade between Africa, America, and Europe. Right from the start, relations between Benin and Portugal involved the trading of enslaved people.[2] In the early sixteenth century when the Kingdom of Benin imposed a ban on the export of male slaves, this trade played a far less significant role in economic relations between Benin and Europe.[3] In the early eighteenth century, however, it was revived once more in Benin in response to the ever-increasing demand for labor on European plantations in the Caribbean and on the American mainland.[4] Although this area of trade relations with Europe and the Americas gradually came to a standstill with the prohibition of the slave trade in the early nineteenth century, serfdom as a social institution continued to exist in various forms on both sides of the Atlantic. The role of slaves in Benin is also reflected in ritual and commemorative objects, from the depiction of unfree people as part of palace society, to suggestions of ritualised killings [**Fig. 2**].[5]

Between Local and Global Art Production

Early trade relations with Europe contributed to Benin's wealth, and courtly art production flourished as a result. Although metal production had existed locally for centuries, the Portuguese imported brass on a large scale. According to recent findings, the brass came from the Rhine Valley in Germany, a center of metalworking in the early modern period.[6] The raw material was molded into horseshoe-shaped rings (manillas) and shipped to Benin [**Fig. 3**].[7] In Benin, brass was used by the court guilds for the production of ritual, commemorative, and prestige objects. The depiction of

2 See, for example, Seibert 2013, 66; Eisenhofer 2007, 55 ff.
3 See Ryder 1969, 65; Harding 2014, 167.
4 See Ryder 1969, 168, 196–238.

5 Just how widespread ritualized killings were in Benin and how the practice developed historically—whether with enslaved people, enemy captives, or criminals—has yet to be conclusively determined by research and is still subject to diverse interpretations. See, for example, Igbafe 1975; Law 1985; Phillips 2021.

6 Skowronek et al. 2023.
7 Metal casting was already widespread in the region before the arrival of the first Europeans, as excavations in Igbo-Ukwu of artifacts from the ninth and tenth centuries indicate.

GROUPS OF FIGURINES WITH SLAVE HOLDER AND ENSLAVED PERSON Fig. 2

| Guild of Bronze Casters or "The Benin Art Society" Nigeria, Kingdom of Benin Mid-20th century | Metal alloy 44 × 38.6 × 18 cm | Musée d'ethnographie de Neuchâtel Inv. no. 63.16.9 Acquired in 1963 |

- Mid-20th century: Guild of Bronze Casters or "The Benin Art Society"
[...]
- Until 1963: Peter Rufus Osunde
- 1963: Acquired by Jean Gabus for the Musée d'ethnographie de Neuchâtel

strangers was always part of the repertoire of images. Sixteenth-century relief plaques, which formed a knowledge archive of Benin's history, depict Portuguese in military uniform with crossbows. Another early example of the kingdom's global relations are the finely decorated ivory salt vessels from the sixteenth century, which were produced in line with European tastes as precious items for royal houses in Europe. In the late nineteenth century, the king's sword-bearers, or Omada, produced carvings that were freer, more ironic and more critical in their commentary on trade with Europeans, than the art of the guilds [Fig. 4].

Fig. 3 Manilla, manufacturer unknown, Europe or Nigeria, 19th or early 20th century, metal alloy, 3.2 × 22.4 × 11.3 cm, Museum Rietberg, inv. no. 2006.140; donated by Ulrike and Rolf Schenk in memory of Paul and Maria Wyss

During the colonial period, relations with Benin were characterized by the relentless demand for raw materials and a desire on the part of Europeans to control trade. This also led to the portrayal of barbaric human sacrifice in Benin as a way to legitimize colonial conquest and resulted in the overthrow of the independent kingdom and the deposition of Oba Ovonramwen in 1897. It was not until seventeen years later that his son Eweka II returned to power under British colonial administration (indirect rule). Oba Eweka II had the palace rebuilt and reactivated the arts of brass casting and ivory carving.[8] With his permission, the guilds began to create works not just for the palace but also for trade. This resulted in the lively production of art for both the local and the global market. Although contemporary techniques such as lost-wax casting closely resemble those of the past, artists today are part of the global geopolitical situation, working, for example, with scrap metal imported from Europe as a raw material. China's steadily increasing economic presence in Africa is also impacting production today, with Chinese bulk purchasing producing scarcity and high prices for the beeswax used in mold making. As ever, the works of Benin's artists create a link between historical and popular memory, past and present, local techniques and the global market.

8 Nevadomsky/Osemweri 2007.

PART OF A JUDGE'S CHAIR, AGBA Fig. 4

Unknown Omada artist Nigeria, Kingdom of Benin 19th century	Wood 31 × 60 cm	Museum der Kulturen Basel Inv. no. MKB III 1034 Acquired in 1899

- 19th century: Made by the Omada (sword-bearers) of the King of Benin
- Before 1897: Estate of Oba Ovonramwen Nogbaisi (ca. 1857-1914), Benin
- 1897: Looted by the British Army, Benin
[...]
- 1899: J. C. Stevens Auction Rooms (London)
- 1899: Acquired by William D. Webster (reg. no. 9486)
- 1899: Acquired by Museum der Kulturen Basel with funds from Paul and Fritz Sarasin

Patrick Oronsaye, Edo historian and great-grandson of Oba Ovonramwen

"You Are Still Holding On To Our Future"

Patrick Oronsaye [PO], an art historian and a descendant of the royal lineage of the Benin Kingdom, spoke with social anthropologist and provenance researcher Alice Hertzog [AH] about the enduring impact of the colonial violence of 1897. The conversation took place on December 13, 2023.

AH The Kingdom of Benin has a long history of relationships with European traders. How did this change under British colonialism?

PO For four hundred years, we maintained relations with white men, from the Portuguese in 1472 to the English in 1553 to the Dutch to the French, and even the Spanish when they reached these shores. The relationships had been cordial—they were based on business from which both parties benefited. But the British crisis started in 1860 when they took Lagos from us: as we say, "When the white man comes, crisis comes."

AH A crisis that culminated in the military attack of 1897?

PO Yes. The year, 1897. The date, February 18. The time, 3 pm. The world of the Benin man, as he had known it for over a thousand years, ended. The British mobilized. Squadrons came from Kingston, Jamaica, from Malta, from South Africa, from the entire West Coast of Africa. To lead the attack they picked Admiral Rawson, who was the commander of the British forces at the Cape.

They started burning and destroying, because the instruction given by the British was to go to Benin, burn down all her towns and villages, and hang the king wherever and whenever he was to be found. After some eight days of fighting, it was as if the enemy had an atomic bomb and all we had was a knife—so you can imagine the result. They blasted their way into Benin City. And our world ended on February 18, 1897.

AH What was left of the city?

PO On February 20, after they'd completed their looting, they set fire to the city. And unfortunately for us, it was Harmattan season—everything was dry. The entire city burned down. What happened was the total destruction of an entire civilization that can only be compared with what the conquistadors did in the Americas: the destruction of the Incas of Peru and the Aztecs of Mexico. That's the only comparison you can draw to the destruction of Benin as a people, as a nation, as a kingdom. A civilization disappeared. Our history. They completely tore up entire pages of our history. Everything we'd worked for, for over a thousand years, disappeared in seventy-two hours.

AH How would you qualify this loss today?

PO The event doesn't encapsulate the loss of just one day. It signifies the loss of our empire, the loss of our prestige, the loss, in global terms, of our massive economic outreach. It represents the loss of our very essence. But above all, it represents the loss of our nature, our self-esteem.

AH How did you learn about the events of 1897?

PO As a child, even as young as five, I was made to understand that the white man represents crisis. And the story of 1897 has been a part of our educational system. It is instilled in primary school, it is discussed in secondary school, it is researched at the university.

If you don't know where you're coming from, you can't know where you are. If you don't know where you are, you can't know where you're going. They took our past, they took our present, and you are still holding on to our future. Every plaque is a history book. A chapter in a history book. Every ivory carving is a book unto itself.

AH In 2023, you traveled to Zurich and visited the Benin artifacts held in museums here: What were your lasting impressions of this visit?

PO Remember, I'm a great-grandson of Oba Ovonramwen, I'm a grandson of Oba Eweka, I'm a nephew of Oba Akenzua and a cousin of Oba Erediauwa. So when I held those objects in my hand in Zurich, my entire DNA reacted. What I have seen for sixty years only on paper, in two dimensions, I now had before me as an object. And all the memories embedded in my family flooded back. Deep pain first and foremost. Joy that they're there. But, above all, regret that I can't take them home.

However, the first thing I said was that Switzerland was not a colonial power. Switzerland never burned down my city. Switzerland never looted my palace. But the Swiss, of their own accord, acting on their own volition, offered restitution. So, as I said, that particular act of the Swiss should be cast in brass.

AH It has been over 120 years since these objects left Benin City. What do they mean to you today?

PO You have to be a Benin man to understand the spiritual, the physical, and the psychological nature of a single artifact. You have to live in the setting in which these objects were made. They are not just artworks. They are not just artifacts. They are visual mnemonics of our very essence. They are records of our history. They are a physical representation of the important events that made us a great civilization. So, for the people of Zurich, when they see an artwork encased in glass, they see an object. But for me, a Benin man, I see my soul encased in glass.

British soldiers posing with looted treasures from the palace during the siege of Benin, 1897

Patrick Oronsaye handling a staff of office at the Völkerkundemuseum der Universität Zürich

Patrick Oronsaye

Phil Omodamwen

Dr. Enibokun Uzébu-Imarhiagbe

Prof. Kokunre Agbontaen-Eghafona

Patrick Oronsaye
Painter, art historian, and cultural consultant in Benin City

"For me, touching these objects is more spiritual than physical. For thirty years, I've been working with these objects, seeing them in visual forms, photographs, whatever. But to see them physically was overwhelming. My gratitude to the Swiss museums is just one expression of this feeling. We didn't come to them. They came to us. So what we're doing today is the result of a positive step taken by the Swiss toward the people of Benin. Our own concept is to return the works to their original owners, because if you don't know where you come from, you can't know where you're going. These works represent our history and our soul. When our children see them, they'll know the glory contained in them."

Dr. Enibokun Uzébu-Imarhiagbe
Department of History, University of Benin, Benin City, and University of Newfoundland

"The art of Benin is a living tradition. It is not dead, it is still being produced. These commemorative heads could be returned, and replicas brought back to continue telling our story and ensuring that Europeans know about a kingdom that still exists and thrives in the forest region of Africa. We are not dead, we still exist. There is nothing mythical about it. I am as real as any other Swiss person living here, with my own tradition and my own personal story."

Phil Omodamwen
Sixth-generation bronze caster, Benin City

"I have been practicing brass casting for over forty years. This work is dying out. In my father's workshop, there were up to fifty of us; now we are fewer than twenty. But I decided to stay cool because I love the bronzes. I promised my father before he died—because it is something that is passed on from father to son—that this work will not die out in my lifetime. I have two sons. My problem is that neither of them wants to take over. I am not happy. Collaboration with Swiss museums is one way of encouraging us. We could make replicas of what they have now, so that the shelves in their galleries are not empty. Because one thing I want everyone to know is that the new will become old."

Prof. Kokunre Agbontaen-Eghafona
Department of Cultural Anthropology, University of Benin, Benin City

"This is a decade for the restitution of cultural objects, especially looted objects like the Benin Bronzes. I believe that it is ethical for some form of restitution and repatriation to be made to the legitimate owners of these objects. I am not advocating for everything to be returned at once. There should be cooperation and discussion. And I strongly feel that, in this regard, Swiss museums should let the Nigerian museums take the lead. They shouldn't tell us (Nigerians) what they think is best. Rather, they should sit down at a table and discuss what is best for the objects and their original owners. This brings about a new climate in museums, with both sides wanting the best to be done for the objects and the people."

Samson Ogiamien
Artist and art mediator, Graz

"Some of the artifacts should be exhibited here in Switzerland to bear witness to my culture and tradition, especially to the Edo people of the diaspora. Our children who were born in Europe can learn more about their history through these objects. However, I also believe that some of the objects should be returned because many of them are ritual objects, and they represent our ancestors. I know this is a difficult decision not only for the museums but also for us in the diaspora. The way they were taken from our kingdom is somehow sad, but some of them should be exhibited in this museum."

Theophilus Umogbai
Former director of the National Museum in Benin City

"As somebody who's from the Kingdom of Benin, I see these objects as mnemonics—'aide-memoires' if you like—of the history of our people. [...] Every household had its altars in the back. An altar is a museum without walls, a museum beyond the showcase. Given that, I wonder how we could take the exhibition to this level, not only in Nigeria but in Switzerland as well. The idea is not to take all the objects away from Switzerland. We need to see how we can put the discussion on a higher level to decide which objects should go back, and which should stay. In both cases, the story of the Kingdom of Benin would be told."

Dr. Josephine Ebiuwa Abbe
Associate professor of theater and performance studies at the University of Benin, Benin City

"What the object means to me personally is that it tells me about my identity and about my history. It takes me back to my ancestors and the stories that my father told me, and my grandfather told my father. These prove the existence of my ancestors before me. The objects will be returned, and they will be in a museum to teach the younger generation how to view their history and tell their children about it. There will be more research, which will increase people's knowledge and be a means of education. It will also improve cooperation with the outside world. It will tell our history not only in the past but also in the present."

Osaisonor Godfrey Ekhator-Obogie
Department of History and International Studies, University of Benin, Benin City

"Our generation grew up having only heard about the looted treasures, and the most intriguing thing for us has been that these objects were also functional objects. Yes, they also served as documentation of our glorious past and of our civilization. These objects were involved in ritual functions. And it is in this respect that we can identify and document them for the future and teach our children about the rich history of Benin. We need to identify these provenances not only from a Western but also from a Beninese perspective."

Samson Ogiamien

Dr. Josephine Ebiuwa Abbe

Theophilus Umogbai

Osaisonor Godfrey Ekhator-Obogie

2

Object Biographies

50 **Ursula Regehr**
Following the Traces of a Commemorative Head: From the Kingdom of Benin to the Museum der Kulturen Basel

54 **Samuel B. Bachmann and Lucky Igohosa Ugbudian**
The Pere at the Bernisches Historisches Museum: The Significance of the Supposedly Inferior

58 **Anja Soldat**
From "Dignitary" to "Warrior" and Back Again: Object Descriptions of an Ama Relief Plaque in the Kulturmuseum St. Gallen

62 **Alice Hertzog**
A Horse, a Rider, and a Head: Fragments of Edo Heritage at the Völkerkundemuseum der Universität Zürich

66 **Floriane Morin**
Questions Surrounding a Carved Ivory Tusk in the Musée d'ethnographie de Genève

70 **Julien Glauser**
Double Context of Injustice: The Relief Plaque at the Musée d'ethnograhie de Neuchâtel

74 **Maylawi Herbas**
Benin–Burgdorf: The Figure of an Oba, Its Provenance, and Its Meaning

78 **Esther Tisa Francini**
An Example of the Role of Provenance on the Art Market: The Hip Mask at the Museum Rietberg

Ursula Regehr

Following the Traces of a Commemorative Head

From the Kingdom of Benin to the Museum der Kulturen Basel

COMMEMORATIVE HEAD OF AN OBA, UHUNMWU ELAO			Fig. 1
Royal Guild of Bronze Casters Igun-Eronmwon Nigeria, Kingdom of Benin Late 16th century	Brass 29 × 21 cm		Museum der Kulturen Basel Acquired in 1899

- Late 16th century: Royal Guild of Bronze Casters Igun-Eronmwon
- Late 16th century: Commissioned by the Royal Palace of Benin
- 1897: Looted by the British Army, Benin
- 1899: Acquired by the MKB from William D. Webster, London

COMMEMORATIVE HEAD OF AN OBA, UHUNMWU ELAO

Categorization: Looted in 1897

Current location: Museum der Kulturen Basel Inv. no. III 1033

Fig. 2 Ancestral shrine, Royal Palace, Benin, Nigeria, 1891

Uhunmwun ne a mu rre o re a ya khian—
It is the head which brought one into the world, which carries one along (Edo proverb)[1]

The head is the seat of our intellect, discernment, determination, personality, vision, communication, and perception[2]—and it was a central motif in Benin figuration.[3] Uhunmwu elao are emblematic representations of the head of the Oba, the supreme authority of the Edo, cast in bronze. Dating back to the late sixteenth century, this commemorative head is an expression of the "Golden Age" of Benin's empire. It was made by the Igun-Eronmwon guild, who oversaw the creation of royal commemorative heads through the lost-wax casting technique.

This Uhunmwu elao bears the marks of various experiences and narratives [**Fig. 1**]. We follow the traces and trajectory of the commemorative head of an Oba and take its various abodes as points of departure to unveil the transformation of an inalienable ritual artifact into a commodity and museum object. Assembling these fragments ignites a curiosity about the future and the reconfigurations that may await it.

[**1**] **Benin, Royal Court**
In the Edo language, "to remember," Sa-e-y-ama, literally means "to cast a motif in bronze." Casting creates lasting images of people and events in the collective memory.[4] Upon the passing of an Oba to the world of the ancestors, the eldest son and successor to the throne was responsible for commissioning a commemorative head and an altar to honor his late father. The Aru erha, ancestral shrines at the royal court in Benin, were places of ritual worship and collective remembrance of the life of previous Obas, the protectors of the kingdom [**Fig. 2**]. The altar established the connection between the worlds of the living and the deceased, between visible and invisible powers.

Uhunmwu elao are emblematic representations of the head of the Oba. An opening at their crest supports a carved elephant tusk, which depicts events and deeds in the monarch's life, enabling his identification. At the same time, it conveys the genealogical histories of the royal lineages, serving to authenticate the rule and authority of the incumbent Oba. When the royal court was looted in 1897, this commemorative head was taken from a shrine and separated from its altar ensemble.

[**2**] **London, Auction House**
The British military's attack had far-reaching consequences for the relationships and exchange between the Edo kingdom and various nations: the pillaging of the palace led to the decline of an influential West African kingdom; Oba Ovonramwen was exiled to Calabar; thousands of artifacts considered inalienable in Benin were taken as spoils and traded on the global market. In London, the art dealer W. D. Webster (1868–1913) sold a large part of the war booty through his auction house [**Fig. 3**]. Benin works commanded high prices, even in the immediate aftermath of the military campaign.[5]

These works gained worldwide admiration owing to their exceptional aesthetics, artistic excellence, and charisma. As a result, they became highly sought after by both public museums and private collectors, solidifying their status as revered "art" from the Kingdom of Benin.

[**3**] **Basel, Museum**
As the first museum in Switzerland, the MKB acquired eight Benin works from Webster in 1899. In its yearbook from 1899, the circumstances were described as follows:

52

Fig. 3 W. D. Webster, letter to the Museum der Kulturen Basel, 1899

"Recall that on account of the destruction of Benin City by the British, there have emerged products of an ancient craft tradition of singular character unsurpassed in the workmanship of the Negro [...]. The spoils of Benin were cast upon the market this year, and we viewed it as our duty to secure for our collection at least some exemplars of a civilization that has now passed from sight for all time."

Once again, the salvage paradigm—to rescue things from a presumed cultural decline—was invoked as an argument for collecting. The fact that these objects were war spoils was not problematized upon their accession to the MKB.

To financially support the acquisition of Benin works, Fritz Sarasin, then president of the museum's commission, mobilized members of bourgeois families and citizens from Basel to cover the total cost of CHF 4,500. Paul and Fritz Sarasin also contributed to the acquisition, to the tune of CHF 1,500; the rest was covered with museum funds.

At the MKB, the objects have been shown as part of exhibitions such as *N-schmiede: Metalltechnik exotischer Völker* (Negro Smiths: The Metal Technology of Exotic Peoples; 1954) and *Ein-Blick in die Geschichte Afrikas* (Looking Into Africa's History, 1994–2003), which mainly focused on the processing of metals, the craftsmanship and technical skills involved in casting and forging, and non-European art forms [**Figs. 4, 5**]. In the permanent exhibition *Memory* (2020–2026), the provenance of the commemorative head of an Oba, that of a dignitary, and a relief plaque have been foregrounded, addressing their violent acquisition. This display invites the public to participate in restitution debates. The different exhibition narratives mirror the shifts in how the Benin works were perceived, as artistic or ethnographic objects, and the move toward an understanding of them as representatives of a sensitive heritage.

[4] A Return from Exile?

In Benin City, the loss of cultural heritage has left significant trauma and a gap in the history of the kingdom. During her research visit to the MKB in 2021, Enibokun Uzébu-Imarhiagbe emphasized that for the Benin people these works are "more than art": "They tell stories, they document history. Here, art was meant to have a functional purpose, apart from aesthetics." Since Uhunmwu elao transmit the genealogy of the Oba and communicate the history of the kingdom, she concluded, "they have a powerful meaning for us."[6]

Fig. 4 Index card from exhibition *N-schmiede* (1954)

Fig. 5 Index card from exhibition *Ein-Blick in die Geschichte Afrikas* (1994–2003)

As the artist Samson Ogiamien explained during his visit, "It is important for some of our artifacts to be exhibited in museums and bear witness to Edo culture and traditions, especially for the diaspora. However, I think that spiritual objects such as Ukhure and Uhun elao are not meant to be in the museums as they are essential to our commemorative tradition and belong to our ancestral shrines."[7]

Since 1935, representatives of the royal court have been reclaiming works scattered across the globe. During the Swiss Benin Forum in 2023, Prince Aghatise Erediauwa emphasized that these so-called "artworks" hold significant spiritual and emotional value and have been taken from ancestral shrines, leaving them empty. In his words, "It is our hope that one day the items that belong in those spaces will come back."[8]

1 Itan Edo—Digital Benin, https://digitalbenin.org/itan-edo (accessed Apr. 9, 2024).

2 I would like to thank Zainabu Jallo and Anna Schmid for the stimulating exchange.

3 See Bradbury 1973, 263; Igbafe 2007, 47; Plankensteiner 2022, 53.

4 See Ben-Amos 1983, 14; Ben-Amos Girshick 2007, 151; Bradbury 1973, 216; Plankensteiner 2022, 53.

5 Bodenstein 2021, 118–119.

6 Enibokun Uzébu-Imarhiagbe, research visit to the MKB, August 31, 2021.

7 https://rietberg.ch/forschung/benin-initiative-schweiz (accessed Apr. 9, 2024).

8 Swiss Benin Forum, Feb. 2, 2023. For footage from the Swiss Benin Forum, see: https://vimeo.com/886438853 (accessed Apr. 9, 2024).

Samuel B. Bachmann and Lucky Igohosa Ugbudian

The Pere at the Bernisches Historisches Museum

The Significance of the Supposedly Inferior

PERE FIGURE GROUP			Fig. 1
Unknown bronze caster Nigeria, Niger Delta Late 19th century	Brass 24.5 × 20 × 14 cm		Bernisches Historisches Museum Donated in 1903

- Late 19th century: Unknown bronze caster, Niger Delta, Nigeria
- 1897: Probably looted by the British Army, Benin
 [...]
- Previous owner until 1903: F. W. Reichert
- 1903: Acquired with funds provided by Sidler, Stein, Ryf, and Baur, facilitated by the
 Völkerkundemuseum Hamburg (today MARKK, Museum am Rothenbaum. Kulturen und Künste der Welt)
- 1903: Donated to the Bernisches Historisches Museum

PERE FIGURE GROUP

Categorization:
Likely to have been looted in 1897

Current location:
Bernisches Historisches Museum
Inv. no. E/1903.326.0004

Fig. 2 Original inventory card of the figure group in Bern

In view of the global dispersion of the Kingdom of Benin's cultural heritage on the one hand, and the heated debate surrounding its history and possible futures on the other, the figure group in the collection of the Bernisches Historisches Museum received peripheral attention [**Fig. 1**]. Although it was donated to the collection back in 1903, the rather rough craftsmanship suggests that it was not made by the royal guilds of bronze casters in Benin. However, the original categorization from the report by the Benin Initiative Switzerland (BIS) in 2023 as "Unlikely to have been looted," which derived from this interpretation, has now been called into question. A better cultural-historical understanding of the figure group and a comparison with similar objects from other collections have given the story a new twist and the categorization is being revised. This artifact, which most probably depicts the vassal king Pere of the Ijaw, illustrates that supposed aesthetic inferiority should not obstruct our view when it comes to the question of historical significance.

[1] **The Vassal States of the Kingdom of Benin**

The figure group shows a dignitary holding his hands protectively over the heads of two subordinates. When it entered the collection in Bern, the original inventory card declared it to represent "the king, leaning on two vassals." When, in September 2021, Enibokun Uzébu-Imarhiagbe and Alice Hertzog visited the collection during their provenance research for the BIS, it was immediately clear to them that it could not be the Oba, as he would not only be dressed differently but would also never be shown in a gesture in which he touched his subordinates. But who was depicted instead?

It is well known that the Benin vassal states, including Owo, Akure, and Ijebu, were very much influenced by Benin arts and crafts. Some, like those in the Niger Delta, for example, had also developed somewhat distinctive styles. But they still produced bronze casts modeled on the iconography and craftsmanship of the Oba's guilds. The difference, however, would be the quality of the casts. Thus, after reviewing the object once again in early 2024, Uzébu-Imarhiagbe, in consultation with different experts in Nigeria, developed the hypothesis that it might be a depiction of Pere or Agadagba, the King of Ijaw, an ethnic group in the swamplands of the Niger Delta.

If this interpretation is correct, it is not unlikely that it was still found in Benin City, since many of the bronzes from the vassal states not only required the Oba's permission to be made but were also presented to him as gifts during festivities. The categorization initially developed by the BIS researchers—that it was "Unlikely to have been looted" due to its rather rough quality—is therefore called into question. A revision of the provenance must start here and include the possibility that pieces that were not originally made in Benin City might still have been looted from the palace [**Fig. 2**].

1 See Müller 2024.
2 See Hoffmann 2010.

[2] The Figure Group's Way to Bern

What can be proven with regards to the provenance is that prior to the little statuette's arrival in Bern, it was owned by the German trader F. W. Reichert. Reichert was involved in the trade with colonial goods at the port of Hamburg.[1] The name of the previous owner is known from a letter dated August 3, 1903, from B. Stölting, a research assistant at the then Völkerkundemuseum Hamburg, to Rudolf Zeller, curator of the Bernisches Historisches Museum. Reichert is also mentioned as a collector in the archives of what is now the MARKK Museum am Rothenbaum in Hamburg, which initially transferred the figure group together with a little altar bell to Bern. These personal and institutional ties mark further indications that the figure might have been a part of the loot.

If we assume, as Patrick Oronsaye did in the BIS report of 2023, that the figure group is a product from a vassal state, then there is a gap in the provenance between its manufacture and its appropriation by Reichert. Given that artifacts like this one were to be found in the court in Benin City as well, and that the museum in Bern was not able to afford the piece in 1903 without the considerable financial support of the influential Bern residents Stein, Sidler, Ryf, and Baur, it cannot be ruled out that it was looted during the events of 1897 [**Fig. 3**].

Fig. 3 Letter from Stölting to Zeller, August 3, 1903, referring to an owner called F. W. Reichert

[3] The Untraceable Paths of *Dubletten*

Given the information on the inventory card, the figure group was passed on to Bern from the Museum in Hamburg as a so-called *Dublette*.[2] *Dubletten* were objects that already existed in a collection in identical or very similar form and were therefore dispensable and tradable from the perspective of the museum that owned them. However, if we look at the other figure group from the Erdmann collection that was already part of Hamburg's inventory back in 1903, we can see how flexible the understanding of similarity must have been, as it depicts completely different persons and gestures. As regards the figure group located in Hamburg, there is no doubt about its connection to the violence of 1897.

Thanks to the Digital Benin database, several more similar figures can be identified. Among these, the ones in the Världskulturmuseerna in Stockholm and in the Nationaal Museum van Wereldculturen in Rotterdam bear the closest likeness to the group in Bern. For the first, its Webster provenance refers directly back to the looting, while for the second—like the one in Bern—the actual moment of colonial acquisition remains speculative. It was purchased by the museum in Rotterdam in 1901 from J. F. G. Umlauff. This comparison between artifacts does not support the original categorization either. On the contrary, it shows that there were similar examples to be found among the looted objects [**Figs. 4, 5**].

Such objects thus remain part of an enormous mass of African heritage located in Europe, whose on-site appropriation has not left any traces in the museums' archives. This is particularly true for the *Dubletten*, which were liberally traded among museums from the early to the mid-twentieth century and therefore represent a major challenge for provenance research. It is also interesting to note here that the declaration of the figure group as a *Dublette* was accompanied by an aesthetic qualification, rating it as an inferior example—a categorization that has persisted to the present day and has also partly led to less attention being paid to it in provenance research.

This original disdain had even more far-reaching consequences, including a lack of exhibitions or research events related to the figure group in Bern before the BIS was launched in 2020. However—and this is the lesson to be learned here—it is often not the "masterpieces" that can tell the most exciting stories from a historical perspective. Ultimately—and since there are legitimate doubts about its original categorization as "Unlikely to have been looted"—we do not know for sure how the artifact came to Europe, and so it finds itself in that gray area of unsatisfactory probability all too familiar to the provenances of African heritage in European museums.

Fig. 4 Figure Group
Unknown caster
Nigeria, Kingdom of Benin,
19th century, brass, 31.2 × 19 cm
Världskulturmuseerna
Stockholm, inv. no. 1907.44.0380

Provenance:
– 19th century: Unknown caster, Kingdom of Benin, Nigeria
– 1897: Looted by the British Army, Benin
– 1897: Acquired by W. D. Webster
– 1907: Donated by Hans Meyer
– Since 1907: Världskulturmuseerna Stockholm

Fig. 5 Figure Group
Unknown caster
Nigeria, Kingdom of Benin,
19th century, brass, 29 × 16 × 12 cm
Nationaal Museum van Wereldculturen Rotterdam,
inv. no. RV-1310-5

Provenance:
– 19th century: Unknown caster, Kingdom of Benin, Nigeria
[…]
– 1901: Purchased from J. F. G. Umlauff
– Since 1901: Nationaal Museum van Wereldculturen Rotterdam

Anja Soldat

From "Dignitary" to "Warrior" and Back Again

Object Descriptions of an Ama Relief Plaque in the Kulturmuseum St. Gallen

RELIEF PLAQUE WITH DIGNITARY, AMA Fig. 1

Royal Guild of Bronze Casters Igun-Eronmwon	Brass	Kulturmuseum St. Gallen
Nigeria, Kingdom of Benin	46 × 38 × 7 cm	Acquired in 1940
16th/17th century		

- 16th/17th century: Royal Guild of Bronze Casters Igun-Eronmwon
- 16th/17th century: Commissioned by the Royal Palace of Benin
- 1888: Oba Ovonramwen Nogbaisi (ca. 1857-1914), Benin
- 1897: Looted by the British Army, Benin
- 1897-1898: British Foreign Office (plaque no. 191)
- 1898: Businessman Casper Andreas Valdemar Blad (?)
- 1898-1928: Museum für Völkerkunde Dresden (reg. no. 16058)
- 1928: Arthur Speyer II, Berlin
- Until 1931: Han Coray (reg. no. BP 3)
- 1931-1940: Schweizerische Volksbank
- 1940: Völkerkundemuseum der Universität Zürich
- Since 1940: Kulturmuseum St. Gallen, previously the Sammlung für Völkerkunde St. Gallen—more specifically, Historisches und Völkerkundemuseum St. Gallen

RELIEF PLAQUE WITH DIGNITARY, AMA

Categorization: Looted in 1897

Current location: Kulturmuseum St. Gallen Inv. no. VK C 3173

Fig. 2 Old index card from the Kulturmuseum St. Gallen, post 1940

"The products of the brass casters, or Igun-Eronmwon, were not only works of art for display but also served as a record of life and events at court.[1] The brass plaques, or Ama, were mounted on the palace walls. They served as a pictorial record of events in Benin's history, much like photographs or paintings. The plates, described as relief plaques, were used as an aide-memoire for oral traditions, as a reminder of the events and people depicted."[2]

The relief plaque from St. Gallen shows a palace dignitary at the court of Benin with a ceremonial sword in his right hand [**Fig. 1**]. In the accession register of the former Sammlung für Völkerkunde St. Gallen, there is an entry from 1940 listing the person depicted as a "knight figure," while the head and neck coverings are described on an index card dating from slightly later as "armored cap and neck armor" [**Fig. 2**]. There the "knight figure" is identified as a "warrior," but this term has been crossed out and replaced by a handwritten "court official." Indeed, the dress and accessories show the person to be a high-ranking member of palace society, as the head and neck coverings are not armor but strands of coral beads and a necklace of leopard's teeth. The left hand rests on the figure's hip, next to a belt featuring a leopard mask worn over a patterned apron. The decorative elements—a rosette form in the upper right-hand corner and two crocodile masks next to the dignitary—and the delicate floral patterns in a quatrefoil motif that cover the entire plaque allude to the water deity Olokun.[3] The plaque dates from the sixteenth or seventeenth century.

[1] British Foreign Office
As Alice Hertzog and Enikobun Uzébu-Imarhiagbe were able to prove through research commissioned by the Benin Initiative Switzerland, this plaque was among the spoils of the British raid of 1897.[4] The decisive evidence for this can be found on a list from 1899 entitled "The Fate of the Benin Plaques" from the British Museum, where the plate is listed as number 191 [**Fig. 3**].[5] The 315 relief plaques on the list were verifiably listed among the official plunder shipped to the Foreign Office in London by the Commissioner of the Niger Coast Protectorate, Ralph Moor, in July 1897.[6]

[2] Museum für Völkerkunde Dresden
The British Foreign Office tasked the British Museum with selling around a third of these objects to private dealers and museums in order to offset the costs of the military expedition.[7] In 1898, the relief plaque was sold to the Museum für Völkerkunde in Dresden (reg. no. 16058), which purchased five further Ama from the British Museum in addition to the St. Gallen plate—all via a certain Mr. Blad, who has been identified as Caspar Andreas Valdemar Blad.[8] As an internationally active businessman, he presumably acted as a broker coordinating the British Museum's sales.[9]

Fig. 3 Fate of the Benin Plaques, 1899, British Museum

Fig. 4 The white stamp from the French customs, "Douanes Françaises—Recette de Paris Chapelle," can be identified on the left of the plaque. In blue letters on the figure itself is Han Coray's numbering "BP3," probably "Bronze Plaque 3." Next to the arm—between the customs stamp and the blue numbering—the Dresden registration number "16058" is more difficult to make out. A beige sticker with the inventory number "C 3173" from the Kulturmuseum St. Gallen can be seen on the upper edge to the right.

[3] Arthur Speyer II and Han Coray

After thirty years in the Dresden collection, the relief plaque was deaccessioned in 1928. The art dealer Arthur Speyer II acquired it in 1928 in exchange for an object in his possession. It is possible that he then sold the plaque to a French gallery, as it bears a French customs stamp on the reverse: "Douanes Françaises–Recette de Paris Chapelle" [**Fig. 4**].[10] What is certain is that it was later acquired—either directly through Speyer or via a Parisian gallery—by the Swiss art collector Han Coray, who listed it in his collection as "BP3–Bronze Plaque 3."[11]

[4] Via the Schweizerische Volksbank to the museum

But the plaque did not remain long with Coray who, at the beginning of the twentieth century, possessed Switzerland's most extensive African collection. In 1931, after the death of his wealthy first wife, Dorrie Stoop, Coray went bankrupt, and his art collection was sequestered by the Schweizerische Volksbank.[12]

The bank instructed the Völkerkundemuseum der Universität Zürich to inventory the objects from Coray's bankruptcy estate and to convey them to various museums and private collectors.[13] This is how the plaque ended up in its current location in the Kulturmuseum St. Gallen in 1940. The Sammlung für Völkerkunde St. Gallen purchased the relief plaque together with seven other objects from the Kingdom of Benin and more than 120 objects from Africa for a total of CHF 5,000, whereby the value of the plaque was estimated at CHF 1,200.[14]

The relief plaque features prominently in numerous publications.[15] According to the records, it has been continuously on display in the permanent exhibition since it entered the collection in 1940. Today, it can be seen in the permanent exhibition room *Welten sammeln* (Collecting Worlds), which was redesigned in 2016 [**Fig. 5**].

[5] Digitization

In October 2023, it was photographed on behalf of the Museum of West African Art (MOWAA) in Benin City, Nigeria, by Femi Johnson, the museum's digitization expert, for the purpose of creating a 3D reconstruction [**Fig. 6**]. The aim of the MOWAA project is to reunite in digital form the more than 850 plaques that are scattered in institutions around the globe and to reconstruct the stories told by the Ama.

Fig. 5 View of the display case for the "Benin Bronzes" in the *Welten sammeln* (Collecting Worlds) permanent exhibition room set up in 2016

Fig. 6 Femi Johnson photographing the relief plaque in St. Gallen, October 9, 2023, on behalf of the Museum of West African Art (MOWAA)

1 See Eyo 1977.
2 Exhibition text from Kokunre Agbontaen-Eghafona, Osaisonor Godfrey Ekhator-Obogie, and Patrick Oronsaye, in: *Dialogue with Benin: Art, Colonialism and Restitution*, Museum Rietberg (August 23, 2024–February 16, 2025).
3 See Ben-Amos 1995; Gunsch 2018.
4 See Hertzog/Uzébu-Imarhiagbe 2023, 30.
5 See Read/Dalton 1899.
6 See Hertzog/Uzébu-Imarhiagbe 2023, 30.
7 See ibid.
8 See Schlothauer 2012, 44–45; Hertzog/Uzébu-Imarhiagbe 2023, 29–30.
9 See Hertzog/Uzébu-Imarhiagbe 2023, 29–30.
10 See also Schlothauer 2012, 44.
11 See ibid., 44–45. Archiv MRZ, photo album Han Coray.
12 See Hertzog/Uzébu-Imarhiagbe 2023, 29–30. See also Malefakis 2016; Oberhofer/Tisa Francini 2016.
13 See Hertzog/Uzébu-Imarhiagbe 2023, 29.
14 The "estimated value CHF 1200" is listed on page 198 of the accession register for 1940. It can also be seen on the old index card of the Kulturmuseum St. Gallen, see Fig. 2.
15 See Krucker 1944; Steffan 1989.

Alice Hertzog

A Horse, a Rider and a Head

Fragments of Edo Heritage at the Völkerkundemuseum der Universität Zürich

FIGURE OF A HORSE RIDER			Fig. 1
Royal Guild of Bronze Casters Igun-Eronmwon Nigeria, Kingdom of Benin 16th/17th century	Brass 59.9 × 18.5 × 37.5 cm		Völkerkundemuseum der Universität Zürich Acquired in 1940

— 16th/17th century: Royal Guild of Bronze Casters Igun-Eronmwon
— By descent to Oba Ovonramwen (r. 1888-1897), Benin
— 1897: Probably looted by the British Army, Benin
[...]
— Until 1931: Han Coray (collector, Agnuzzo)
— 1931-1940: Schweizerische Volksbank
— 1941: Sammlung für Völkerkunde der Universität Zürich

FIGURE OF A HORSE RIDER

Categorization: Likely to have been looted in 1897

Current location: Völkerkundemuseum der Universität Zürich Inv. no. 10007

[1] A Commission from Oba Esigie

The equestrian figure was produced by the Royal Guild of Bronze Casters Igun-Eronmwon and was most likely commissioned by Oba Esigie (ca. 1504–1550). Horse-riding figures have been dated from the mid-sixteenth to the late seventeenth century. This has been confirmed by a thermoluminescence analysis of a similar horseman figure currently held at the Museum of Liverpool, dated to 1560 (with a margin of error of forty years) [**Fig. 1**].

[2] Three Centuries of Royal Lineage

Over the course of three centuries, the figure would have been preserved within the palace of the Kingdom of Benin and its ownership passed down the lineage of nineteen Obas, entering into the possession of Oba Ovonramwen when he was installed in 1888. It is most likely that British military personnel looted the figure during the 1897 attack on Benin.

[3] Traded as Art in Europe

The figure was taken to Europe and sold on the art market. By the late 1920s, it had entered into the possession of Swiss collector Han Coray, who was in the process of accumulating a vast collection of African art. The purchases were facilitated by the wealth of his father-in-law, Adriaan Stoop, who was a successful Dutch colonial mining engineer and oil prospector in Java. The equestrian figure was shown in Coray's private villa and in exhibitions in Lugano (1931), Munich (1931), Winterthur (1931), and Basel (1932) [**Fig. 2**].

Horse riders regularly figure as a motif on bronze relief plaques, cuffs, combs, and staffs, and more rarely as individual figures, as in the case of this equestrian.

Who is this rider? Various museum scholars have put forward their hypotheses over time: for Felix von Luschan, the figure represents a foreigner;[1] for Philip Dark, a Yoruba warrior;[2] William Fagg thought it was an emissary from the northern emirates.[3] More recent scholarship suggests that the figure is an Oba—possibly Oronmiyan (ca. 1170–1200)[4] or, more likely, Oba Esigie (ca. 1504–1550),[5] one of the three great warrior kings of Benin.

The horse rider in Zurich is particular. It arrived in the collection headless and was later matched up with a new head cast from another museum piece. In the 1950s, museum staff thought they had located the corresponding head in the British Museum. A cast of this head was made in the 1970s and attached to the rider's body. More recent analysis suggests, however, that the two pieces do not match.

Thus, the rider highlights the fragmentation of Edo cultural heritage, where, following the looting of 1897, elements of the same object were distributed across museums and private collections worldwide. It is also a highly mobile piece that over the years has been shown in at least fourteen museums in Europe, America, and South Africa. However, it has not been seen in Nigeria, where for the Benin people it holds cultural and spiritual significance, since the end of the nineteenth century.

The rider is one of fourteen Benin objects at the Völkerkundemuseum der Universität Zürich that are likely to have been looted in 1897 and were acquired from the estate of the Swiss collector Han Coray in 1940.

Fig. 2 The rider featured in the exhibition *Afrikanische N-kunst und ihre Beziehungen zur Hochkultur: Sammlung Coray*, Munich, 1931

Fig. 3 The horse rider on display without its head, 1940s

[4] Seized by a Swiss Bank
Following the death of his wife, Dorrie Stoop, in 1928, Han Coray went bankrupt. His assets, including his collection of African art, were seized by the Schweizerische Volksbank (later Credit Suisse, today UBS) [**Fig. 6**]. The Völkerkundemuseum der Universität Zürich was tasked with their appraisal and with helping facilitate the sale of the artifacts.

[5] Acquired by a University
Under the directorship of Hans Jakob Wehrli and with the support of his scientific assistant Elsy Leuzinger, the Völkerkundemuseum der Universität Zürich acquired a selection of works from Han Coray's collection in 1940—including the equestrian figure, which was first displayed in the university's main building [**Fig. 3**]. After the collection moved to its current location in the Old Botanical Gardens, where it was put on public display in the newly opened Völkerkundemuseum, the rider was part of the permanent exhibition from 1980 to 1983; it was then shown from 1986 to 1989 in *Die Kunst Schwarzafrikas* (Art from Black Africa), and in 1996 in *Afrikanische Kunst aus der Sammlung Han Coray* (African Art from the Han Coray Collection).

[6] A Head Is Found
In the 1950s, a bronze head thought to match the rider was identified in the British Museum. Looted in 1897, it was acquired from the collection of Major W. A. Crawford Cockburn. In 1953, a cast made from the neck of the rider's head was sent to Zurich and deemed to fit. In 1959, the rider, in turn, was sent to the British Museum to be photographed together with the head for Elsy Leuzinger's publication *Afrika – Kunst der N-völker* (see p. 116). In 1970/71, on the occasion of the exhibition *Die Kunst von Schwarz-Afrika* at the Kunsthaus Zürich, the British Museum sent the original head to Zurich for a copy to be made at the Landesmuseum and mounted on the headless rider [**Fig. 4**]. In 2023, however, new analyses from the restoration team at the Völkerkundemuseum and the Archäologische Sammlung der Universität Zürich concluded that the two pieces do not correspond.

[7] Six Years on the Road, Eleven Years on Loan
The figure, with the cast head from the British Museum, was shown in a traveling exhibition of the Coray collection, organized by the Basel Art Center. The tour, which ran from 1996 to 2002, saw the figure exhibited in Germany (Baden-Baden, Rosenheim), the US (Utica, Toledo) [**Fig. 5**], Canada (Quebec), the US again (Pittsburgh, Nebraska), South Africa (Durban), and finally back in Switzerland (Lugano). The figure was then loaned to the Museum Rietberg in order to augment its Benin collection when an extension building was opened in 2007. It was returned in 2018 in the context of the exhibition *Die Frage der Provenienz* (The Question of Provenance).

Fig. 4 Kunsthaus Zürich director René Wehrli placing the head from the British Museum on the rider, 1970

Fig. 5 The horse rider on show at the *Soul of Africa* exhibition, Utica, 1998

[8] The Rider Returns
Since its return to the Völkerkundemuseum der Universität Zürich, the rider has been held in the museum storage facility. In 2022, the Benin Initiative Switzerland established that the rider, because it is representative of early royal court art, is likely to have been looted. In March 2024, Nigeria requested the transfer of ownership of the rider and thirteen other objects from the Kingdom of Benin, held in the Völkerkundemuseum der Universität Zürich.

Fig. 6 Image of the equestrian figure without head from the photo documentation of the Schweizerische Volksbank, ca. 1930.

1 Luschan 1919, 126–129.
2 Dark & Forman 1960, 49–50.
3 Fagg 1978, 42.
4 Karpinski, 1984.
5 Nevadomsky 1986.

Floriane Morin

Questions Surrounding a Carved Ivory Tusk in the Musée d'ethnographie de Genève

ALTAR TUSK, AKEN'NI ELAO			Fig. 1
Royal Guild of Ivory Sculptors Igbesanmwan Nigeria, Kingdom of Benin 17th/18th century	Ivory 155 cm, Ø 12 cm	Musée d'ethnographie de Genève Acquired in 1948	

- 18th century: Royal Guild of Ivory Sculptors Igbesanmwan,
 commissioned by the Royal Palace of Benin, possibly by Oba Eresonyen ca. 1735
- By descent to Oba Ovonramwen (r. 1888-1897)
- 1897: Looted by the British Army, Benin
[...]
- August 11, 1898: Sold at J. C. Stevens Auction Rooms for £2 2s. 0d.
- 1898-1902 (?): William D. Webster (1868-1913, dealer, London), Webster no. 5443
- June 3, 1902: Sold at J. C. Stevens Auction Rooms for £7 10s. 0d. (?)
[...]
- Until 1948: Berkeley Gallery (William Ohly, London)
- 1948: Acquired by the Musée d'ethnographie de Genève for CHF 2,571.30

ALTAR TUSK, AKEN'NI ELAO

Categorization: Looted in 1897

Current location: Musée d'ethnographie de Genève Inv. no. ETHAF 021934

Fig. 2 Detail of the burnt surface of the ivory tusk

[1] A Commission from Oba Eresonyen

This carved ivory tusk was produced by the Igbesanmwan, the Royal Guild of Ivory Sculptors, and was probably commissioned by Oba Eresonyen (r. ~1735–1750) at the beginning of his reign, in memory of his late father, Oba Akenzua I (r. ~1713–1735)

[2] 160 Years of Royal Commemoration

Throughout the reigns of the seven monarchs who succeeded Oba Akenzua, this elephant tusk was part of an ancestral altar within the Royal Palace of Benin. It probably stood vertically, held in place in an opening made for it at the top of a sculpted brass head. Its carvings thus became a historical record attesting to the glory of the powerful Kingdom of Benin. We don't know what bronze head it was that held it, or if this head even still exists. The tusk was separated from the head when British troops looted the royal ancestral altars during the attack on Benin in 1897, during the reign of its last protector, Oba Ovonramwen Nogbaisi (1888-1914).

[3] The Scars Left by the Great Fire of Benin

The tusk bears the scars of the Great Fire, which practically destroyed the entire city of Benin during the British attack of 1897 [**Fig. 2**]. Like many other of the ivory tusks that were taken from the ancestral altars by the military force and left on the ground in an exterior central courtyard of the Oba's palace, this one was severely burnt when the palace buildings were set on fire. The resulting charring makes it difficult to read the carved motifs on its surface. Like thousands of other royal objects, this tusk, which is presently part of the MEG's collection, was looted to be sold in London.

This majestic elephant tusk was once to be found as a commemorative object in a shrine within the Royal Palace of Benin [**Fig. 1**]. Here, on altars devoted to deceased kings, were placed sacred objects, "bronzes," and ivories, items that today are scattered throughout the world.

According to a typological study conducted by Barbara W. Blackmun,[1] the tusk now housed in the Musée d'ethnographie de Genève (MEG) could be one of the oldest held in Europe. It could, in fact, be one of the earliest tusks to have carvings covering its entire surface. Oba Ozolua the Conqueror (r. ~1483–1504) appears as the main figure right in the center of the tusk. On either side of him, there are military figures—Edo, as well as Portuguese and Dutch. It's possible, for example, to pick out Dutch traders and warriors amongst the archers and figures on horseback. Other carvings record priests, servants, merchants, and musicians, as well as animal figures—leopards, crocodiles, fish, birds, etc. The heraldic figure, fish-tailed and wearing a crown from which a pair of crocodiles rear up, is a reference to the deified past rulers of Benin.

In 2020, the artist Roland Udinyiwe Ogiamien, who has inherited the Edo cultural tradition, described the MEG tusk as follows: "A very uncommon carved ivory depicting many past Obas of the Kingdom of Benin. Zooming into the pictures, I can recognize Oba Ohen, Oba Ehengbuda, and many others. This is one of the objects of the ancestral altar and shrine of the Oba."[2]

Fig. 3 Eugène Pittard, "L'Art du Bénin: Nouvelles acquisitions du MEG," *Les Musées de Genève*, 10 (November–December 1950): 3

[4] **Doing the Rounds of London's Auction Houses**

Having been sold at the J. C. Stevens Auction Rooms in London on August 11, 1898, the ivory tusk was then in the possession of the antique dealer William D. Webster (1868–1913) from 1898 until 1902, at which point he put it back up for auction at Stevens and sold it on June 3, 1902. The inventory number (5443) that Webster assigned to it can still be seen on the tusk and corresponds to its description in the sales catalog no.19, published in 1899, where it features as lot 92: "A very large Elephant Tusk, carved with figures of warriors, reptiles, fish, etc., very much worn with age, and partly damaged with fire in the taking of the city, 67 inches long (Benin City) £25 0s. 0d."[3]

[5] **Fifty Years Later...**

At this time, we are still missing the information that would allow us to determine the whereabouts of the ivory tusk between 1902 and 1948 and whose hands it passed into. It is highly likely that it stayed on English soil because its next documented appearance is in the Berkeley Gallery in London, which was owned by the celebrated art dealer William Ohly (1883–1955). Ohly then sold the tusk on to the MEG for the sum of CHF 2,571.30.

[6] **Benin Bronzes at Any Price**

During the years prior to World War II, the MEG was a modest institution. Its director, Eugène Pittard, a professor of anthropology, was looking for ways to fill the gaps in its African collections to make it competitive with other Swiss and European museums. The first Benin Bronze was acquired after fierce negotiations with Hans Himmelheber in 1932 and was a Uhunmwu-Ekue, a pendant mask that had also been looted during the 1897 attack on Benin.[4] With the museum lacking the funds to acquire an ivory tusk, so iconic of the royal art of Benin, Pittard was able to persuade nine patrons to contribute to the acquisition of this coveted object. The collection continued to be enriched throughout the 1950s, with the museum buying more reasonably priced artifacts on the Parisian art market and whenever opportunities for such purchases presented themselves in Geneva [**Figs. 3, 5**].

[7] **Questions from the Edo Experts during the Swiss Benin Forum**

On the last day of the Benin Forum in February 2023, the Nigerian delegation examined the ivory tusk which had been taken from its case in the reference exhibition for this purpose [**Fig. 4**]. His Royal Highness Prince Aghatise Erediauwa, Prof. Kokunre Agbontaen-Eghafona, Theophilus Umogbai, and Patrick Oronsaye expressed their amazement at the extremely worn but still lustrous surface of the tusk. The delegation found this sheen strange and were riveted by the barely discernible carved designs. The great age of this tusk is well known, but there is a mystery surrounding the enduring luster of its surface.

Fig. 4 His Royal Highness Prince Aghatise Erediauwa, Prof. Kokunre Agbontaen-Eghafona, Theophilus Umogbai, and Patrick Oronsaye examining the pieces from Benin in the MEG's reference exhibition hall, February 3, 2023

Fig. 5 Display case with the tusk in the Africa Hall in the late 1940s

1 B. Blackmun, personal communication with the author, May 5, 2014.

2 In 2020, the Ogiamien family kindly passed on to Floriane Morin their thoughts about the objects from the Kingdom of Benin presently housed in the MEG. In his comments on the ivory tusk, Roland Udinyiwe Ogiamien specified that he had consulted with Obuezzar S. Owalbi, head of the National Gallery of Art, Benin City, and Efemene Isaiah Ononeme, professor at the School of Arts, University of Benin, Benin City.

3 Webster 1899.

4 Correspondence between Hans Himmelheber and Eugène Pittard in 1932, Archives de la Ville de Genève. On Himmelheber, see www.africa-art-archive.ch (accessed May 9, 2024).

Julien Glauser

Double Context of Injustice

The Relief Plaque at the Musée d'ethnograhie de Neuchâtel

RELIEF PLAQUE, AMA			Fig. 1
Royal Guild of Bronze Casters Igun-Eronmwon Nigeria, Kingdom of Benin 16th century	Metal alloy 41 × 29 × 4.5 cm		Musée d'ethnograhie de Neuchâtel Acquired between 1949 and 1952

- 16th century: Royal Guild of Bronze Casters Igun-Eronmwon, commissioned by the Royal Palace of Benin
- By descent to Oba Ovonramwen (r. 1888-1897)
- 1897: Looted by the British Army, Benin
- [...]
- Until 1898: Heinrich Bey & Co (trading company, Hamburg)
- 1898: Königliches Museum für Völkerkunde, Berlin (reg. no.: IIIC 8356)
- 1923: Arthur Speyer II
- Before 1933: Acquired by Hans Lachmann Mosse
- 1933: Forced transfer of ownership to the Rudolf Mosse Stiftung GmbH
- 1934: Sold at the Lepke Auction House in Berlin to Friedrich Wolff-Knize for 210 Reichsmark
- 1941: Confiscated by the Gestapo in Vienna
- 1941: Acquired by the Völkerkunde Museum in Vienna
- 1947: Restituted to Friedrich Wolff-Knize, Paris
- 1949: Inherited by Annie Wolff-Knize
- After 1949: Acquired by the Musée d'ethnographie de Neuchâtel
- 1952: Added to the inventory of the Musée d'ethnographie de Neuchâtel

RELIEF PLAQUE, AMA

Categorization:
Looted in 1897

Current location:
Musée d'ethnograhie de Neuchâtel
Inv. no. 52.1.1

Produced in the sixteenth century by the Royal Guild of Bronze Casters Igun-Eronmwon, for the Royal Palace of Benin, this brass plate depicts a Portuguese soldier [**Fig. 1**]. It was removed from the palace walls during the looting of Benin in 1897 and sold by the Hamburg auction house Bey & Co, in around 1898/99, to the Königliches Museum für Völkerkunde in Berlin. During the period of hyperinflation between 1921 and 1923, the museum offered it, along with other artifacts, to Arthur Speyer II. The plaque then entered the Lachmann-Mosse Collection, which was owned by a Jewish publishing family. In 1933, the art pieces were seized along with all the family assets and transferred by the Nazi government to the so-called Rudolf Mosse Foundation GmbH, before being sold on. Another entrepreneurial family of Jewish origin, the Wolff-Knizes, bought it and incorporated it into their collection. Following the Anschluss in Austria, their property was also confiscated, and the family fled to Paris. The Wolff-Knize Collection was moved in 1941 by the so-called Gestapo Office for the Disposal of the Property of Jewish Emigrants (Vugesta) to be stored at the Völkerkundemuseum in Vienna, and the museum acquired it the following year. After the war, the ethnographic pieces were returned to the Wolff-Knize family. After Friedrich Wolff-Knize died, his wife Annie and his son Peter sold all the Benin pieces in multiple batches. In 1952, the plaque was listed at the Musée d'ethnograhie de Neuchâtel (MEN).

[1] **Relief Plaques**
These plaques were usually cast from manilla, the trading currency used by merchants from Europe, and not only had a decorative function but also served as a visual mnemonic for the official history of the kingdom, illustrating important events. This particular relief panel shows attributes typically used to depict Portuguese figures in Benin art: a standing man wearing a tunic, trousers, and a buttoned jacket. His face, with its slightly aquiline nose, ends in a medium-length beard cut horizontally. On his head, a half-spherical helmet, decorated with two stripes, sits on top of long straight hair. His right hand is placed on his vest, and his left is holding a sword hanging from a shoulder strap. The background is decorated with plant motifs, Ebe-Ame, or river leaf, and dotted lines. The plant depicted is linked to the water deity Olokun, who is associated with wealth and fertility, which was also a reference to the Europeans arriving by water. If we consider the entire corpus of known brass plaques depicting Benin's first contacts with Europeans—the Portuguese—they underline the long-standing relationship between the two kingdoms, dating back to the fifteenth century. These stereotypical representations of the Portuguese show the importance of the established ties, which include trade, political, and cultural relations. Portuguese mercenaries even became part of the Benin army. The relief plaques form a significant part of what is known as the Benin Bronzes. About 850 to 900 plaques are in public and private hands today, mostly in the United Kingdom, Germany, and Austria. Some of them are in museums in North America.[1]

[2] **Museum für Völkerkunde**
In 1898 and 1899, the Königliches Museum für Völkerkunde in Berlin purchased two lots of Benin works: fifty-five pieces from Erich Schmidt, the honorary consul in Lagos, and over three hundred from the auction house Bey & Co. The latter purchase included the *Platte, Europäer mit Schwert* (Plaque, European with Sword) [**Figs. 2, 3**].

Fig. 2 Felix von Luschan, *Die Altertümer von Benin*, plate 4C, 1919, where the inventory number of the Museum für Völkerkunde in Berlin can be seen, III C 8356

Fig. 3 Page 332 of the inventory book from the Königliches Museum für Völkerkunde in Berlin listing eleven objects from the Kingdom of Benin, most of them brass plates, with III C 8356, *[Platte mit] Europäer*

[3] The Speyer Family

During the period of hyperinflation in the Weimar Republic that lasted from 1921 to 1923, the museum was forced, however, to sell some of its pieces for financial reasons. In 1923, art dealer Arthur Speyer II bought eight Benin plates, including a *Platte mit Europäer* (Plaque with European).

The Speyers were a dynasty of dealers in so-called ethnographic works.[2] While studying zoology in Jena, Arthur (Karl Hans Friedrich August) Speyer I (1858-1923) developed an interest in ethnography. He initiated several biological research activities in Strasbourg and Berlin and worked as a scientific consultant. In the 1920s, he was in contact, as an art dealer, with various Swiss museums. His son Arthur (Max Heinrich) Speyer II (1894-1958), the most active dealer in the family, immersed himself in natural science from an early age and took over the business from his sick father. He took advantage of the scientific network the latter had developed—and with it the sale of "duplicates" by German museums—to acquire and then resell pieces to European museums and gallery owners. His son Arthur (Johannes Otto Jansen) Speyer III (1922-2007) inherited the North American collections—while the rest of the collection was divided between his sister Jeannette Speyer and his mother Anne Marie Speyer—and made a career as a specialist in North American art.

Fig. 4 Cover of the catalog for the auction of the Mosse Collection, 1934. The brass plate is shown with the lot number 179b on page 40.

Fig. 5 The collectors ran a men's fashion shop, Kniže & Co., in a building designed by architect Adolf Loos in Vienna, ca. 1910.

[4] The Mosse Family

Rudolf Mosse was a German publisher and philanthropist interested in art and literature. He amassed a large collection in his home, the Mosse-Palais on Leipziger Platz. After his death in 1920, his daughter, Felicia Lachmann-Mosse, inherited his estate. Her husband, Hans Lachmann-Mosse, took over the running of the publishing company. The Lachmann-Mosse family expanded the collection by acquiring the brass plaque. In 1933, after the Nazi Party took power, the family company and assets were confiscated and transferred to the state through a foundation. The next year, the collection was sold at an auction organized by Rudolph Lepke's Kunst-Auctions-Haus in Berlin. The plate was then listed in the Lepke catalog of the 1934 auction. The catalog mentions two bronze heads and eight reliefs from Benin, including an *Europäer mit Vollbart und Säbel* (European with a Full Beard and Sword) [**Fig. 4**].[3]

[5] On to Austria

At the Lepke sale, six pieces that probably correspond to those bought by Arthur Speyer II from the Königliches Museum für Völkerkunde in Berlin were acquired by the Viennese art collectors Friedrich and Annie Wolff-Kniže.[4] In 1938, after the Anschluss in Austria and because of its Jewish origins, Friedrich Wolff-Kniže's family-owned menswear business, Kniže & Co. was forcibly sold to four of its employees. The same year the collector couple had to flee Vienna. As their art collection was part of the sale, they sent it back from Paris. During that process, a bronze plaque was donated to the Musée de l'Homme in Paris. In 1941, the collection was seized by the Gestapo and the ethnographic part was transferred to—and purchased by—Vienna's Völkerkundemuseum. After World War II, Jewish families who had been despoiled were able to apply for the return of their lost works of art. After 1947, under the supervision of US forces, the ethnographic pieces were returned to the Wolff-Kniže family. Following the death of Friedrich Wolff-Kniže in 1949, his widow Annie and his son Peter sold all the Benin pieces in several batches [**Fig. 5**].

[6] Musée d'ethnographie de Neuchâtel

From 1945 to 1978, Jean Gabus, ethnologist and museologist, was director of the MEN and the Institut d'ethnologie de Neuchâtel. In September 1952, the report of the museum's commission announced a first payment of CHF 3,000 for the purchase of the relief plaque; the second installment would be paid the following year.[5] The seller from whom the MEN acquired the piece has not yet been identified. From the 1970s until 1999, the Benin plaque was shown in the museum's permanent exhibition alongside other works from Africa.[6]

1 Gunsch 2018.

2 Kaehr 2001, 197–203; Schultz 2016, 5–8.

3 Rudolph Lepke's Kunst-Auctions-Haus 1934, 40.

4 According to a note by Claudia Marwede-Dengg, dated November 30, 2022, that was sent to Alice Hertzog as part of the Benin Initiative Switzerland research project. Knize is today written without the "ž."

5 Extract from the minutes of the MEN committee meeting of September 17, 1952. MEN archives.

6 In 1963, Jean Gabus complemented the relief plate with modern Benin objects acquired by Peter Rufus Osunde in Benin City.

Maylawi Herbas

Benin–Burgdorf

The Figure of an Oba, Its Provenance, and Its Meaning

FIGURE, OBA			Fig. 1
Unknown workshop Nigeria, Benin City (?) 2nd half of the 20th century	Metal alloy 10 × 40.5 × 11 cm		Museum Schloss Burgdorf Donated in 1989

- 2nd half of the 20th century: Unknown workshop in Nigeria, Benin City (?)
[...]
- Unknown date: René Gardi (1909-2000), Switzerland, collector
- Unknown date: Elsy Thöni-Vogt (1906-unknown), Burgdorf
- August 28, 1989: Gifted to Museum Schloss Burgdorf

FIGUR, OBA

Categorization: Not looted in 1897

Current location: Museum Schloss Burgdorf Inv. no. ES-10100

Fig. 2 Phil Omodamwen's workshop, March 26, 2022

The Schloss Burgdorf Museum houses three collections: a collection devoted to regional history, an ethnological collection, and a collection of gold objects. The ethnological collection comprises around 7,700 objects and 1,300 photographs from Asia, Africa, the Americas, and Oceania. Through its participation in the Benin Initiative Switzerland (BIS), Schloss Burgdorf has been able to gather valuable experience in provenance research, which in turn has prompted it to engage in further research and projects.

The object biography of the figure of a king (Oba) [**Fig. 1**] sheds light on the relationship between the collector Elsy Thöni-Vogt and her mother Anna Vogt-Heiniger as well as on her motives—which were partly sentimental—for bequeathing the figure to the Schloss Burgdorf Museum. Like the figure of the Oba, many of the other objects in the ethnological collection were amassed by citizens of Burgdorf and donated to the museum.

[1] The Figure of an Oba and Art Production post 1897

The standing solitary figure represents a new art form that was produced both for the market and for ancestral shrines after 1897. Such figures were fashioned after historical models that were interpreted as portrayals of important kings of the past, such as Oba Ewuare "the Great" or Oba Esigie.

The BIS categorized the figure from the Schloss Burgdorf Museum's ethnological collection as "Not looted in 1897" but instead produced in the twentieth century by the Igun-Eronmwon guild of bronze casters and acquired by private collectors.[1] After Oba Ovonramwen was deposed and sent into exile in 1897, the British colonial government reinstated his son Oba Eweka II in 1914 as an instrument of indirect rule. In order to revive the kingdom, the latter loosened the monopoly that bound the guilds to the palace. This led to the establishment of the Benin Arts and Crafts School and to a new phase of intensive art production, some of it for the Western market. This was not limited to replicas but also yielded new artistic forms.[2]

Some of the guilds of bronze casters that were revived after 1897 are still active today in the center of Benin City.[3] Nevertheless, the number of local bronze casters is steadily decreasing. At the Benin Forum in Zurich, Phil Omodamwen provided a fascinating insight into the world of bronze casting:

"I have been practicing brass casting for over forty years. This work is dying out. In my father's workshop, there were up to fifty of us; now we are fewer than twenty. Having not got what they wanted from the job, most of my cousins are in Europe or Switzerland looking for greener pastures. But I decided to stay cool, because I love the bronzes. I promised my father before he died—because it is something that is passed on from father to son—that this work will not die out in my lifetime. I have two sons. My problem is that neither of them wants to take over. I am not happy. Collaboration with Swiss museums is one way of encouraging us. For example, we could make replicas of what they have now, so that the shelves in their galleries are not empty. Because one thing I want everyone to know is that the new will become old" [**Fig. 2**].[4]

Other accounts by bronze casters can be accessed on the online platform Digital Benin.[5]

[2] René Gardi, a Swiss Collector and Dealer

René Gardi (1909–2000) was a Bern-based travel writer, photographer, and filmmaker. He studied mathematics, physics, and zoology at the University of Bern, worked as a high-school teacher in Brügg, near Biel, from 1932 to 1945, and then became a freelance writer and traveling speaker. He was known for his travelogues and illustrated books about Cameroon, the Sahara, and New Guinea.[6]

The archive reveals that the Museum für Völkerkunde Burgdorf, then under the direction of the collection's curator Walter Staub, engaged in intensive correspondence with René Gardi in 1988 and 1989. Gardi's article titled "Die heitere Kunst des Sammelns" (The Genial Art of Collecting; apparently unpublished) probably dates from this time.[7] The article contains a good deal of anecdotal information about how the author expanded his collection. On the first page he writes: "During all my travels to Africa, I was always collecting on the side, and invariably did so with the greatest pleasure.

76

Fig. 3 Correspondence mentioning René Gardi, 1989

Much of what I purchased in the southern Sahara, in the Sahel, and especially in northern Cameroon is now in some museum or other, in Munich, Basel, or Bern, and now in Burgdorf as well." During his stay in Africa, he spent several weeks in villages purchasing objects and artifacts. He writes of one of his forays into the markets: "Of course, no one expected me to pay the first price named, not even the seller. I haggled with a clear conscience, but when I realized one trader was reluctant to part with his bow and another with his lance, I soon gave up." In the same article, Gardi records another instance, relating how he acquired a pair of sandals from an old man— this time not at the market: "Smiling, the old man handed me his worn-out sandals and a pretty piece of ornamented handicraft and went off to buy two pairs of brand-new sandals with the money he had received [...]. Trading in Africa is agreeable when both parties are happy at the end of it."

René Gardi is mentioned as the previous owner of the Oba figure in the correspondence between the museum and Elsy Thöni-Vogt [**Fig. 3**].[8] From a number of detailed statements in the above-mentioned article, we can deduce that Gardi most probably acquired the Oba figure as a souvenir.

[3] The Vogt Family
According to documents in the archive, Elsy Thöni-Vogt (1906–unknown) donated several objects from Africa to the museum from 1981 onward. In a handwritten letter, she mentions that she made the endowment in memory of her mother, adding at the end: "My mother was from Burgdorf" [**Fig. 4**].[9] Another letter, dated June 26, 1989, is addressed to Max Vogt-Hofer, Elsy's brother, who acted as an intermediary between his sister and the museum.[10] In the next letter, the curator, Walter Staub, assures Thöni-Vogt that the Benin figure will immediately be added to the display case formerly known as the "West Africa" vitrine.[11] In the final letter from the museum to Thöni-Vogt, dated August 28, 1989, the museum informs her that Gardi purchased the bronze alloy figure in Benin.[12] The figure's provenance is thus quite transparent. Nevertheless, a number of other questions arise. Thöni-Vogt says that she donated the objects to the museum in memory of her mother, which makes us wonder whether these objects originally belonged to her or what the connection was between them and her mother.

Following her endowment, the figure of the king, or Oba, was shown for a short time in

Fig. 4 Handwritten correspondence from Elsy Thöni-Vogt, 1981

Fig. 5 Viewable storage space, Kirchbühl 11, 2019

the exhibitions at Kirchbühl. According to the database and the archive, it has not been on display to the public since then and is currently in storage [**Fig. 5**].

[4] The Schloss Burgdorf Museum
In 2023, a temporary post for provenance research was created at the museum with financial support from the Swiss Federal Office of Culture, and the project "On the Essence of Things" was launched. Its aim is to use a participatory approach with a diverse project team to bring a variety of voices into the museum. The project team is currently putting together a series of topics and objects from the permanent exhibition for a new video tour. From spring 2025, these will be accessible to the public both in the museum and on the website.[13] Provenance research is an important tool in the discussion about colonial cultural heritage, providing key information about the countries and cultures from which the objects in the ethnological collection originated.

1 Hertzog/Uzébu-Imarhiagbe 2023, 26.
2 Ogbebor 2022, 246.
3 Ibid.
4 Interview with Phil Omodamwen on the current situation of the guilds, January 30, 2023.
5 See Digital Benin website, https://digitalbenin.org/.
6 Lerch 2005.
7 René Gardi, "Die heitere Kunst des Sammelns," n.d., archive of the Ethnological Collection Museum Schloss Burgdorf.
8 Curator Walter Staub to Elsy Thöny-Vogt, letter, Bern, August 28, 1989, archive of the ethnological collection, Museum Schloss Burgdorf.
9 Elsy Thöny-Vogt to the Museum für Völkerkunde in Burgdorf, memo, n.d., archive of the ethnological collection, Museum Schloss Burgdorf.
10 Curator Walter Staub to Max Vogt-Hofer, letter, Bern, June 26, 1989, archive of the ethnological collection, Museum Schloss Burgdorf.
11 Ibid.
12 Curator Walter Staub to Elsy Thöny-Vogt, letter, Bern, August 28, 1989, archive of the ethnological collection, Museum Schloss Burgdorf.
13 "On the Essence of Things," Schloss Burgdorf, https://schloss-burgdorf.ch/en/museum/activities/on-the-essence-of-things/ (accessed Apr. 8, 2024).

Esther Tisa Francini

An Example of the Role of Provenance on the Art Market

The Hip Mask at the Museum Rietberg

| PENDANT HIP MASK, UHUNMWU-ẸKUẸ | | | Fig. 1 |

Royal Guild of Bronze Casters Igun-Eronmwon
Nigeria, Kingdom of Benin
17th/18th century

Brass, iron
21 × 12.8 × 5.2 cm

Museum Rietberg, Zurich
Acquired in 2011

– 17th/18th century: Royal Guild of Bronze Casters Igun-Eronmwon
– 17th/18th century: Commissioned by the Benin royal family, Benin
– 1888: Oba Ovonramwen Nogbaisi (ca.1857–1914), Benin
– 1897: Looted by the British Army, Benin
[...]
– July 1,1902: J. C. Stevens Auction Rooms Ltd.
– July 1,1902: William D. Webster (1868–1913), dealer, 14356
[...]
– Date unknown: Hans Meyer (1858–1929), dealer
– ca. 1930; Ernst Heinrich, Stuttgart
– 1960s: Sibylle Zemitis, Heinrich's daughter, USA
– 2009: Loed and Mia van Bussel, dealers, Amsterdam
– 2010: Jacques Germain, dealer, Montreal
– 2011: Museum Rietberg, Zurich

PENDANT HIP MASK, UHUNMWU-ẸKUẸ

Categorization:
Looted in 1897

Current location:
Museum Rietberg, Zurich
Inv. no. 2011.9

"For centuries, hip masks have been part of the ceremonial regalia worn by palace officials in the Kingdom of Benin. They are worn by chiefs of all ranks as a pendant attached to the bunched cloth of the wrap on the left hip as part of ritual attire. The masks are related to the brass pectoral masks sent to vassal rulers and also to the ivory pendant masks worn by the Oba during the ceremony honoring the Iyoba, the queen mother.

The strip down the nose is made of copper, while the pupils are made separately of iron set in a wax model before casting in order to create a color contrast. A headband of coral beads, called a Udahae is worn round the forehead, with strings of beads cascading down both sides of the face. The lower part of the face is framed by a symbol of the rising sun—Owen I bae de ku, the sun never misses a day—with a row of loops from which miniature bells were suspended; these are now broken off."[1]

This mask was commissioned from the Royal Guild of Bronze Casters by the Oba and was kept in the palace in Benin until the British raid of 1897. It was not until around 1900 that the hip mask acquired a monetary value as loot, and in 1902 it was sold at the J. C. Stevens Auction Rooms. It has not been possible to determine precisely who the vendor was.

One of Stevens's major clients was the auctioneer and dealer William D. Webster. He most likely sold the high-quality cast on to Hans Meyer, a researcher and collector from Leipzig, who had exhibited his collection at the city's Grassi Museum. The mask thus became both a museum object and a focus of scholarly research.

Later, Meyer sold the hip mask to Ernst Heinrich, a German dealer and private collector, in whose family it remained as a collector's object for decades. After the Heinrich family broke up the collection, the mask found its way via the art trade into the possession of the Museum Rietberg, and hence into a display case. This acquisition was made in connection with the touring exhibition *Benin: Könige und Rituale* (Benin: Kings and Rituals), which was shown in Vienna, Berlin, Paris, and Chicago in 2007/2008.[2] Unlike today, the Webster provenance was considered a seal of quality when the mask was purchased in 2011—a hallmark of an old work made before 1897.

[1] Clients
The mask was commissioned from artists employed at the Benin court by the Oba, who was thus its original owner. He kept the royal insignia in safe custody for Edo society as a form of collective cultural heritage. This hip mask was made by the Guild of Bronze Casters in the seventeenth or eighteenth century and kept in the royal palace [Fig. 1]. The last owner was Oba Ovonramwen, who reigned from 1888 to 1897.

[2] The British Army
In addition to the looting carried out by the British government to cover the costs of war, the soldiers themselves also appropriated objects as war spoils. Most of the goods looted in February 1897 and the following months were shipped directly to England. The big shipping companies transported the huge volume of artifacts directly to British ports, from where they were sold on.

[3] The J. C. Stevens Auction Rooms
In August 1897, the J. C. Stevens Auction Rooms organized the first major auction of the objects from Benin, which were regarded as war trophies and loot brought back by the British. As well as cultural objects, there were also zoological, botanical, and many other artifacts on offer. According to the online platform Digital Benin, more than two hundred objects from Benin passed through this auction house.

[4] The Ethnographic Dealer William D. Webster
William D. Webster was a major client of J. C. Stevens Auction Rooms, who sold numerous objects from the 1890s onwards as an auctioneer and dealer [Fig. 2]. An important branch of his business was auction catalogs, which he began publishing in 1895. Between 1899 and 1901, he organized major Benin auctions, in the course of which more than nine hundred Benin works passed through his hands. The vendors were British soldiers and colonial officials. In 1904, Webster had his own holdings auctioned off by Stevens.

Fig. 2 William D. Webster with carved ivory, from a photo album of the British Museum, ca. 1898/99

[5] **William D. Webster's Ledger**
The hip mask was not publicly auctioned but sold by private contract. The number 14356 in Webster's store ledger clearly corresponds with that on the inside of the hip mask at the Museum Rietberg. Dealers' ledgers are not always publicly accessible, which makes provenance research more difficult. In this case, however, they can be found in the archive of the Te Papa Tongarewa Museum in New Zealand and have recently become accessible in digital form.

[6] **Meyer: Researcher, Collector, and Colonial Politician**
The publisher's son Hans Meyer (1858–1929) was involved in the German colonial project as a geographer, scientist, and politician. He traveled to, among other places, East Asia and North America and went to East Africa several times. Up until his death, his extensive Benin collection was on permanent loan to the Völkerkundemuseum in Leipzig, of which he was a patron, endowing the museum with numerous collections and supporting it financially [**Fig. 3**].

[7] **Grassi Museum für Völkerkunde zu Leipzig**
Following their arrival in Europe in 1897, the Benin objects immediately became highly sought after, and German museums strove to expand their collections to include such items. Today, the largest Benin holdings worldwide are held by museums in Germany. A key figure in this development was Felix von Luschan (1854–1924), who became directorial assistant at the Museum für Völkerkunde in Berlin in 1897 and was appointed director in 1905. He made major acquisitions for the Berlin museum, both from London dealers and from German trading companies. He also compiled the first comprehensive monograph on the subject, in which he outlined the aesthetic value of the objects and classified them as works of art.

[8] **Ernst Heinrich and His Heirs (ca. 1950–2008)**
At some point—we do not know exactly when—either Hans Meyer himself or his widow sold the hip mask that had been in the collection. It surfaced again in the 1950s, by then in the possession of the dealer and collector Ernst Heinrich in Bad Cannstatt near Stuttgart. Heinrich cultivated contacts with a large network of museums, fellow dealers, and private collections [**Fig. 4**]. In 1967, part of Heinrich's collection was auctioned in London by Parke-Bernet. Another part of the collection, which included this hip mask, initially remained in the family, in this case with his daughter Sibylle Zemitis, a resident of North America.

[9] **Mia and Loed van Bussel (1935–2018)**
In the course of the international exhibition *Benin: Könige und Rituale*, shown in Vienna, Berlin, Paris, and Chicago in 2007/8, the hip mask reappeared on the market. However, the gallerist couple Mia and Loed van Bussel, who had been dealing in art from Africa and Oceania since the 1950s, were unsuccessful in their attempt to sell it. The hip mask circulated on the art market for a number of years, eventually crossing the Atlantic again, this time to Montreal. From there, the art dealer Jacques Germain offered it for sale to the Museum Rietberg. Today, objects that have connections with the looting of 1897 are no longer on the market.

[10] **Museum Rietberg, Zurich**
In 2011, the Museum Rietberg was able to acquire the mask with the help of private sponsor Regula Brunner-Vontobel. Although the museum knew that it had been appropriated by force during the British military campaign, at that time this was regarded as evidence of its age and authenticity. The hip mask was incorporated in the museum's permanent exhibition, but it was not until 2018 that the reverse was shown in order to highlight its provenance—its forced appropriation, in other words [**Fig. 5**].[3] From 2022 to 2024, the mask was also on display as part of the exhibition *Wege der Kunst* (Pathways of Art), a critical survey of the histories of the objects and collections held by the museum.[4]

Fig. 4 Ernst Heinrich's collection in his home in Bad-Cannstatt, near Stuttgart, ca. 1950

Fig. 5 Reverse of the pendant hip mask showing the Museum Rietberg inventory number and the number from William D. Webster

Fig. 3 Room containing parts of the Benin collection in Hans Meyer's villa in Leipzig, ca. 1929

1 Exhibition text from Kokunre Agbontaen-Eghafona, Osaisonor Godfrey Ekhator-Obogie, and Patrick Oronsaye, in *Dialogue with Benin: Art, Colonialism and Restitution*, Museum Rietberg (August 23, 2024 – February 16, 2025).
2 On this, see the extensive exhibition catalog, Plankensteiner 2007.
3 *Die Frage der Provenienz: Einblicke in die Sammlungsgeschichte* (The Question of Provenance: Unwrapping Collection History), Museum Rietberg, December 1, 2018 – September 30, 2019, curated by Esther Tisa Francini.
4 *Wege der Kunst: Wie die Objekte ins Museum kommen* (Pathways of Art: How Objects Get to the Museum), Museum Rietberg, June 17, 2022 – March 24, 2024, curated by Esther Tisa Francini in cooperation with Sarah Csernay.

3

Cooperations

84 Yann Laville
More Than Illustration: A Scenographic Approach to Provenance

88 Samson Ogiamien and Floriane Morin
Se-Ya-Ma Means Both "To Cast in Bronze" and "To Remember"

92 Samuel B. Bachmann and Lucky Igohosa Ugbudian
Benin Arts from the Margins

96 Alice Hertzog and Alexis Malefakis
"I Lay My Hand on the Ivory and Feel the Red Benin Soil": Diaspora Encounters in the Museum Storage Facility

100 Solange Mbanefo
Designing an Afrocentric Benin Exhibition

104 Josephine Ebiuwa Abbe and Michaela Oberhofer
Energy from the Source: Co-curating Benin Arts and Performance

108 Zainabu Jallo and Ursula Regehr
In Full View: Benin, Nigeria Dialogue and Multi-perspectivity

112 Voices

[Fig. 1] The relief plaque in the exhibition

More Than Illustration

A Scenographic Approach to Provenance

In 2023, the Musée d'ethnographie de Neuchâtel (MEN) developed *Cargo Cults Unlimited*, an exhibition dealing with the complex theme of the "globalized economy." Part of it focused on the production, circulation, and consumption of material goods, with a strong emphasis on research-led examples. In this context, the curators soon decided to show the "relief plaque," an object from the museum's collections that had just been thoroughly investigated as part of the Benin Initiative Switzerland (BIS).[1]

The purpose was to stress the economic dimension in the various tumultuous episodes that marked the plaque's itinerary. From triangular trade to Nazi looting, from the colonization of Africa to the financial chaos that shook Germany in the 1920s, all these dramatic events were also deeply rooted in commercial concerns. The plaque presented an opportunity to survey six hundred years of economic history and to question an old assumption when it comes to business: namely, that economic relationships foster understanding, shared interests, and peace.

From the start, all the project members agreed on a minimalistic scenography, with no other objects to interfere with the visitors' engagement with the piece. The main challenge was to find a way to present the many tragic stages in the work's biography in a suitable way. Different options were explored (including text, sound, and photography) until it was finally decided to hang the piece with pronounced light/shadow contrast in a vertical architecture loosely inspired by the Shoah memorial in Paris [Fig. 1]. The contextual elements would come from an accompanying graphic composition. For this, references leaned toward the famous eleventh-century Bayeux tapestry, which gives an account of the many historical events of the Norman conquest of England in a single frame, depicting them in visual form, just as Edo brass plaques do. The style needed to be transposed, though, which in turn led us to consider working with a Nigerian artist.

An in-house researcher started reaching out to her contacts, but, unfortunately, none of the artists she knew in Lagos were available at the time. A colleague working for the "Digital Benin" project helped us out of our predicament. She suggested a young designer she had recently commissioned: Osaze Amadasun. Besides his varied and impressive skill set, Osaze was a perfect fit for the undertaking: he was born in the region of the Kingdom of Benin and was experienced in international collaborations and knowledgeable about traditional court art as well as current repatriation issues.

An agreement was reached in July 2023, but the work only started after the summer break. This meant tight deadlines for an opening in December. Luckily, the artist proved to be a fast worker. Drawing on selected bits of information from the BIS research, Osaze sent his first draft in September. It contained no less than forty-six pages of mood boards, a full sketch with alternative versions [Fig. 3], and spatial renderings. His efforts contributed a great deal in terms of documentation—putting images to people, buildings, or events we mostly knew only from words. It came to validate the idea of a graphic approach without text. The frieze would stand by itself, as a work inspired by street art, comic books, and Benin court aesthetics [Fig. 2]. Retrospectively, the choice proved wise, allowing us to exploit three distinct levels of information (object, drawing, and text) without the awkwardness of the didactic panels usually found in museums. At this point, we went back and forth with the artist, discussing the reading order, the place and size of each event, and the boundaries and coherence between the different stages.

A second proposal was discussed in late September. At this point, Osaze sent animated films to explain his process of experimentation, and the museum team began to check all of the details, as it would do for a text nearing publication. This precaution proved useful, as one whole episode had simply been forgotten along the way: the dispossession of Rudolf Mosse, the first private owner of the plaque in Germany during the rise of the Nazi regime. Once again, Osaze managed to find images of the protagonist and to fit them into the frieze [Fig. 4]. After this and some other minor adjustments, he started the detailed pen drawing. The final work arrived on November 22. It was immediately sent to print and installed in the exhibition in an uninterrupted flow of electronic communication.

Beyond satisfying aesthetic and conceptual concerns, the installation of the work had an unexpected echo in a different part of the exhibition: one dealing with Lagos's Computer Village, a bustling market that filled the digital gap in Western Africa and made up for the absence of global corporate firms in the area. In hindsight, the fast and ultra-efficient online collaboration with Osaze Amadasun attested to this high-tech turn in Nigeria.

On a broader scale, it is also worth mentioning that collaborations between European museums and artists from the "source communities" are very much in fashion. As with any trends, results vary greatly depending on a complex balance of intentions and chance occurrences. In the present case, we were extremely fortunate to find a partner with considerable talent, an in-depth knowledge of the topic, and clearly defined opinions on colonial issues, as well as sufficient distance to allow him to consider them in a larger historical context. Viewed from Neuchâtel, this collaboration also verified an old belief: namely, that in order to produce interesting results, those involved must go beyond their conventional roles and occupy what might be called a "middle position." One where artists do not hesitate to take part in scientific debate (Osaze was eager to mobilize his knowledge on the Kingdom of Benin), and curators, in turn, are not afraid to intervene in artistic matters. Such a balance is obviously difficult to establish and requires judgmental or moralizing stances to be left at the door.

1 See Glauser on pp. 70–73 in this volume.

[Fig. 2] The frieze in its final setting

[Fig. 3] Detail of the sketch

[Fig. 4] Detail of the frieze

[Fig. 1] Bronze mask of Iyagbon and the performance of *Iyagbon's Mirror* displayed in the capsule *Se-Ya-Ma* as part of the MEG exhibition *Remembering: Geneva in the Colonial World*

Se-Ya-Ma Means Both "To Cast in Bronze" and "To Remember"

Between May 3, 2024, and January 5, 2025, the exhibition *Remembering: Geneva in the Colonial World* is presenting the capsule Se-Ya-Ma [Fig. 1]. It has been conceived by Samson Ogiamien [SO], an Edo sculptor, now living in Graz, Austria, in collaboration with Floriane Morin [FM], who is responsible for the African collections at the Musée d'ethnographie de Genève (MEG) and curator of the exhibition. The artist Samson Ogiamien chose this verb in the Edo language to represent the space in which his work—both sculptural and performative—enters into a dialogue with the objects in the MEG that originate in the Kingdom of Benin, were looted by British colonial troops in 1897, and then dispersed across the art market during the twentieth century. As a result, this immersive space, which is specifically dedicated to the Benin Bronzes, their status as museum artifacts, and their future, represents a new chapter in the conversation that began in 2020 around the performance *Iyagbon's Mirror*.

FM Samson, how has your personal journey brought you to these artifacts, which are generally known as the Benin Bronzes?

SO I was born and raised in Benin City. Through my family line, I belong to the royal dynasty of the Ogiamien on my father's side. On my mother's side, I am a descendant of the Royal Guild of Bronze Casters. I grew up in a culture and a tradition where art is our way of documenting our history. When I was a child, I grew up seeing these artifacts and sculptures in my grandfather's palace, and I took part in the bronze casting in Benin City.

So I was influenced by my culture, by its tradition and by these objects. When I left Nigeria for Austria in 2004, I saw our artifacts for the first time, the very objects that I had been told about when I was in Nigeria. I had never had the opportunity to see these objects before coming to Austria, to Vienna. It was then that I began to reflect on how I could contribute to the question of restitutions.

FM Our relationship developed around *Iyagbon's Mirror*—a performance dedicated to the anguish of objects that have been transformed into museum objects and severed from their ritual purposes—which you co-wrote with the Franco-Swiss company Onyrikon, and which the MEG co-produced in the spring of 2022. At the center of this multidisciplinary performance of theater, music, and dance is the bronze mask Iyagbon, which you created. Can you tell us about this work and what's at the heart of it?

SO Iyagbon is a goddess of the Edo pantheon. She watches over all the living creatures of the Edo, its culture, its objects. I designed this mask as a bronze made using the lost wax method and then cast it in Benin City in 2020 in collaboration with the royal casters, the Igun-Eronmwon. The mask is symbolic, as Iyagbon is a work that is at once traditional and contemporary. It represents a new generation of African art coming to Europe to reconnect with its ancestors' art in the diaspora.

The performance begins in a Western museum. An art object is stolen so that it can become a ritual object. At first, the museum visitors are taken by surprise, but then they are invited to join in what is happening and follow the artists in a procession that takes them out of the museum. Once outside, an artistic ritual is orchestrated, demonstrating how we can create a magical dimension around an object and inviting the audience to experience it for themselves. The Onyrikon performers interact with the sculpture during the performance, and a new ephemeral body for the mask is created in situ each time *Iyagbon's Mirror* is performed. Halfway through, I call on the mask of Iyagbon and explain to it that it was never meant to be exhibited in a museum, nor were any of the other Edo objects in the collections supposed to be here.

FM Through *Iyagbon's Mirror*, visitors to the MEG have been confronted emotionally with the problematic origins of these collections. Art makes us aware of the issues directly, on an emotional level, which is not the case with theoretical discussions. How do you see this debate about the restitution of the Benin Bronzes unfolding in the future?

SO These artifacts are not simply art. We are talking about religious works, ceremonial objects. For me, they are not works of art because they are not regarded as such by the people who are invested with our cultural heritage. They are spiritual objects that illustrate our history and document our memories. That makes them our archives. I believe that many museums don't understand exactly what they are exhibiting. This is why I consider it so important for there to be collaboration between the artists and people from the cultural sphere [Fig. 2]. It is precisely what the MEG is doing right now—giving an opportunity to the artists who have this connection with the objects to share their perspectives with the museums and wider public. The aim is to inform and educate them about what is being exhibited in the studios and exhibition halls.

FM I know that you are committed to sharing these artistic experiments and museum events in Benin City itself. What are you planning?

SO The second phase of *Iyagbon's Mirror* has actually been under way in Benin City since 2023! We began by creating a workshop for students from the history and international studies programs at the university centered on the mask itself and its creative process [Fig. 3]. Their numerous questions gave the artists plenty to respond to, and sculptor Eric Ogbemudia, who is the present secretary of the Igun Royal Bronze Casters Guild, and Emmanuel Ikponmwosa Inneh and Osayamen Ogbomo, who are both guild members, duly obliged. The idea throughout the workshop was to explore the multiple facets of *Iyagbon's Mirror*, understand its symbolism, and decipher its historical references to facilitate meaningful discussions about the intersection of Benin's art and history within today's sociocultural context.

[Fig. 2] The Nigerian artists Phil Omodamwen and Samson Ogiamien in the MEG's conservation and restoration workshop during the Swiss Benin Forum

[Fig. 3] *Iyagbon's Mirror* Phase II: workshop at the University of Benin

Benin Arts from the Margins

This essay takes a fresh look at the Benin objects held by the Bernisches Historisches Museum (BHM). As the curator of the museum's Africa collections (Samuel B. Bachmann) and a research fellow at the University of Bern (Lucky Igohosa Ugbudian), working on the Swiss Nigerian initiatives for the restitution of Benin artifacts, we investigated the provenances and meaning of the objects from the Kingdom of Benin held in Bern. By combining our perspectives, we were able to provide new insights into the figure group, the Eroro [Fig. 1], and the pendant mask [Fig. 2]. The collaboration led to a shared understanding of the significance of marginalized artifacts in relation to the narrative of the so-called masterpieces from Benin.

ALTAR BELL, ERORO Fig. 1

| Unknown bronze casterNigeria, Niger DeltaLate 19th century | Brass11.5 × 6.5 × 6.5 cm | Bernisches Historisches MuseumInv. no. E/1903.326.0005Acquired in 1903 |

- Late 19th century: Unknown bronze caster, Nigeria, Niger Delta
- 1897: Probably looted by the British Army, Benin
[...]
- Previous owner until 1903: F. W. Reichert
- 1903: Acquired with funds provided by Sidler, Stein, Ryf, and Baur, facilitated by the Völkerkundemuseum Hamburg, today MARKK Museum am Rothenbaum - Kulturen und Künste der Welt
- Since 1903: Bernisches Historisches Museum

PENDANT MASK UHUNNMWU EKUE Fig. 2

| Unknown bronze casterNigeria, Benin CityFirst half of the 20th century | Brass/bronze18.0 × 11.0 × 7.0 cm | Bernisches Historisches MuseumInv. no. E/1995.325.0389Donated in 1995 |

- First half of the 20th century: Unknown bronze caster, Nigeria, Benin City
[...]
- 1949: Acquired by Ernst F. Rohrer
- 1995: Donated by the heirs of Ernst F. Rohrer
- Since 1995: Bernisches Historisches Museum

The Pitfalls of Stylistic Interpretations

Based on the first phase of research of the Benin Initiative Switzerland (BIS), the three artifacts mentioned above belong to the category "Unlikely to have been looted in 1897" [Fig. 3]. As such, they were declared "not emblematic of Benin Royal court art" on account of their "rudimentary casting"; "owing to their design and the quality of the casting, they appear to have been produced post 1897."[1] The BIS report, however, was also very clear on the fact that "for all of the objects in this category, there is also no evidence that they were definitely not looted, hence the remaining uncertainty."[2] This is, of course, also due to the fact that, in the absence of clear evidence, the categorization was derived solely from stylistic interpretations.

Back in 1919, the Austrian ethnographer and anthropologist Felix von Luschan's (1854–1924) stylistic judgment was highly critical when he declared the figure group "very bad, […] very crude and of grotesque ugliness; [it] can only be of interest to us as samples of the deep decay of an ancient artistic practice."[3] While the severity of judgment differs, there seems, however, to have been a certain continuity in the aesthetic categorization of the group. Interestingly, this view seems to also be shared, in part, by Nigerian expert Patrick Oronsaye, who concluded—from these artifacts' "poorer quality"[4]—that they were produced pre 1897 by neighboring communities or vassal states in the style of Benin art and gifted to the Oba.

Margins Are a Matter of Perspective

While Germany and the United Kingdom are the epicenters of debates on the restitution of Benin artifacts, Switzerland has remained at the margins. This could be attributed to a number of factors. Switzerland was not by any means a colonialist empire, despite the fact that its citizens—both private and public actors—benefited enormously from colonialism. Additionally, the number of Benin objects in Swiss public museums is comparatively low, with only ninety-six pieces, compared to the several thousand Benin objects held in the collections of the two countries mentioned above. Coupled with this is the lack of comparable Nigerian and African diaspora communities in Switzerland, who, in European countries, have helped to galvanize the restitution debates.

The artifacts in the Bernisches Historiches Museum can be used as telling examples to understand how these Swiss collections of Benin heritage can nevertheless have relevance in global history. Oronsaye's claim that the artworks were produced and donated to the Oba by vassal or neighboring communities, but not by the guilds of bronze casters in Benin itself, was further strengthened by specialist and co-author of the BIS report Enibokun Uzébu-Imarhiagbe in 2024 [Fig. 4]. These experts show that the artifacts in Bern are not only on the periphery of the debate in Switzerland and Europe but also attest to a lesser-known aspect of the ingenious craftsmanship of the powerful and magnificent kingdom in present-day Nigeria.

Even if these objects supposedly lack the emblematic features associated with the more admired Benin objects, one should not forget that they are still part of the heritage and represent the histories, practices, and ideas of people. They might help us understand how people outside the court, perhaps outside the guilds, or even outside Benin City used the radiance of the kingdom and its famous arts and crafts to their own individual ends. They remind us that, in addition to the well-known history of the kings and their regalia, there are also the unknown stories of common people and their communities. They are therefore of great importance, precisely because they have been marginalized in the discourse and thus enable a change of perspective away from the focus on so-called masterpieces.

Changing Narratives

The artifacts in the Bern collection were seen as being of little relevance for historical or contemporary political and scientific discourses. The "grotesque ugliness" of the figure group described by Luschan in 1919 fits the Eurocentric world view of his time, in which the outstanding quality of the Benin Bronzes made such an impact in Europe primarily because they were so easily comparable with the central narratives of European feudal history. As historians trying to collaboratively reconstruct the history of Benin heritage today, we must be careful not to fall prey to the seductive simplicity of this one-dimensional way of explaining global history and must also pay tribute to the margins of dominant historical narratives. From this point of view, these three artifacts constitute part of a precious material culture that potentially sheds light on people's everyday experience.

1 Hertzog/Uzébu-Imarhiagbe 2023, 24, 25, 27.
2 Ibid., 25.
3 Luschan 1919, 332 ff.
4 Hertzog/Uzébu-Imarhiagbe 2023, 25.

[Fig. 3] All artifacts from the Kingdom of Benin in storage at the Bernisches Historisches Museum

[Fig. 4] Enibokun Uzébu-Imarhiagbe and Alice Hertzog inspecting the Benin pieces at the Bernisches Historisches Museum

[Fig. 1] Peter Owerei and Famous Imade with a commemorative head at the Völkerkundemuseum der Universität Zürich

Alice Hertzog and Alexis Malefakis

"I Lay My Hand on the Ivory and Feel the Red Benin Soil"

Diaspora Encounters in the Museum Storage Facility

Whether looted, gifted, or bought, artifacts from non-European cultures in the Völkerkundemuseum der Universität Zürich create opportunities—and a certain obligation—for renewed encounters with members of their originator communities. In a post-migrant society like Switzerland, members of those communities might live just next door to the museums that house their cultural heritage. But despite this physical proximity, the two are often worlds apart.

In this museum, the Benin holdings are held in a storage facility, deep inside a converted air-raid shelter with meter-thick concrete walls, alarmed and professionally secured with controlled room temperatures. Such standards are intended to ensure that as museum objects they are preserved for future generations. However, their preservation comes at a cost: not only are these artifacts physically distant from Benin City but even Edo community members residing in Zurich are unaware that objects originating from their homeland are held in the museum.

Famous Imade and Peter Owerei are representatives of the Edo United Club of Switzerland, a diaspora organization based in Zurich [Fig. 1]. With their help, the Völkerkundemuseum has started to establish relationships with the Edo community, inviting members of the club and their families to engage with the artifacts. During our first encounter, Famous Imade, a taxi driver, expressed disbelief upon seeing the artifacts. He had driven countless times past the museum to pick up bankers at nearby Paradeplatz, but it had never occurred to him that there were Benin artifacts just a few hundred meters away from him. His friend Peter Owerei shook his head, recalling the time he had taken his young daughter to the *Tutankhamun* exhibition many years ago at the Zurich cultural venue Halle 622. How could it be that she had visited a touring exhibition of Egyptian burial treasures but had never stood in front of the treasures from the Oba's palace, located right here in Zurich?

These initial conversations, tinged with both joy and regret, are the first steps of a re-entanglement of historical Benin objects with concerned communities here in Zurich.[1] They follow on from a period of sustained conversations with experts from the academic and cultural heritage sectors in Nigeria and members of the Oba's Palace in Benin City in the context of the Benin Initiative Switzerland. The discussions have enriched our understanding of these "objects" as fragments of Benin's material archive that have been lost and are urgently needed in Nigeria. Cooperations with international partners in Nigeria also led to more local preoccupations: What affordances might the Benin objects offer Edo diaspora communities in Zurich? A certain urgency drove this question: if they were to return to Nigeria, should the museum not at least guarantee that local Edo groups here had had the opportunity to engage with the objects before they departed?

The Edo Club returned again to the storage facility, this time accompanied by fellow members of the association, wives, teenagers, and young children. Some wore traditional white robes with red corals, others "Benin City" baseball caps [Fig. 2]. In the storage facility, they put on green latex gloves to handle the objects, and mothers pulled out their phones to show the teenagers YouTube videos of the Edo rituals associated with them. Young men tried to lift the bronze pieces, testing their strength, whilst animated discussions took place on the species of bird featured on the bird-of-prophecy staff.

Afterwards, one of the parents reflected on what it meant for them to bring their children into contact with the pieces, how in years to come they might say, "Mummy took me somewhere, Daddy took me somewhere, and we saw something no one else has seen for a long time." Another mother spoke of the difficulty of raising second-generation teenagers: "When they come home, we want them to behave like Africans, and when they go outside, they have to behave like Swiss […] but when they come now, they see these objects they have never seen before, so it makes them aware of what it means to be African" [Fig. 3]. What stands out here is the role such collections might play for parents and offspring navigating their identity and sense of belonging in a post-migrant society.

And yet again, this encounter was tinged with sorrow. One visitor, in handling the artifacts, re-experienced the looting and destruction of Benin. Talking of 1897, he commented: "At times, we think it's maybe fiction, but it's a reality, a reality which we are seeing here today. When I lay my hand on that ivory, I try to scan through my body, and I see the black and red Benin soil still inscribed in it, and it rouses feelings in me about what really happened, so I put myself in the position of experiencing that day when all the things were taken away from us." And despite the interest in having access to the pieces in Zurich, our guest had no desire that they should remain here. "I'm very happy to see that we are in the process of returning this material back home." And then he added, "I beg the authorities to extend their efforts to make sure that these things are brought back home," before breaking out in a song of praise to the Oba, a reminder of who these objects, in the eyes of Zurich's Edo diaspora, really belong to today.

1 The notion of re-entanglement and affordances draws on the work of Paul Basu as presented in the exhibition *[Re:]Entanglements: Colonial Collections in Decolonial Times* at the Museum of Archaeology and Anthropology, Cambridge, June 22, 2021–April 20, 2022. See also Basu 2011, 42.

[Fig. 2] Godwin Osarenren and Samuel Nosa with a carved ivory tusk at the Völkerkundemuseum der Universität Zürich

[Fig. 3] Itohan Evelyn Obasuyi Frei debating the role of the Benin Bronzes in educating Afro-Swiss teenagers at the Völkerkundemuseum der Universität Zürich

[Fig. 1] Author's rendering of the entrance to the exhibition with a photo of Omoregie Osakpolor

Solange Mbanefo

Designing an Afrocentric Benin Exhibition

In Dialogue with Benin: Art, Colonialism and Restitution is a temporary exhibition at the Museum Rietberg in Zurich. Incorporating research from the Benin Initiative Switzerland (BIS) project, it endeavors to reclaim decolonial methodologies for framing cultural heritage that go beyond restitution, fostering a sense of mutual responsibility between complementary global perspectives.

The curatorial team—which consists of an art anthropologist, a historian, a performance scholar, and myself, an Afropean architect[1]—has embarked on a journey to explore innovative forms of transcultural collaboration. The subject-objects,[2] constituting art from the Kingdom of Benin, were exhibited until recently as classic works of art in the museum's African collection, where they have now become the focus of provenance research for projects on colonial archives and collections.

In my dual role as exhibition designer and co-curator, I envision guiding visitors on an immersive journey to explore an Afrocentric design approach that centers on the term "multi-perspectivity" as a key strategy of decolonization.

Multi-perspectivity in African Symbolism

My design research is grounded in innovative reflections on multi-perspectivity: symbolic philosophy, vernacular architectural typologies, and Benin mythology.[3] The term symbolic philosophy was inspired by Ron Eglash's scientific research on Indigenous African design typologies in the field of mathematics. This exploration of the exhibition's design language identified a repeating—fractal—pattern that is evident in various cultural aspects of the rich knowledge systems in Africa.[4]

Fractals are usually found in nature and can be seen in objects like snowflakes or shells, where a pattern looks the same whether you zoom in or out, because it repeats itself at every scale. Within the Eurocentric narrative, the term was coined by mathematician Benoit Mandelbrot in 1975. However, fractal patterns reveal unique geometries notably present in detailed art forms commissioned by the Oba of the ancient kingdom of Benin, extending from decorative design motifs on brass plaques to the complex strategic layout of Benin's defensive moats, which spanned an impressive 16,000 kilometers.[5]

While exploring Benin mythology, the curatorial team selected the ancient Edo proverb, Agbon r'obion,[6] which translates to "The world is a triangle." This proverb, rooted in triangle numerology,[7] sparked an investigation into the interplay between fractal geometries and triangles, reflecting the existential concept of infinity in African symbolism [Fig. 1].

This ethos led to the exploration of lenticular structures, which display images on a base configuration of extruded triangles: these give visitors physical control over a binary visual illusion that can only be perceived from an individual's unique perspective [Fig. 2].

Exploring the Exhibition

As they enter the exhibition, visitors are immersed in a series of lenticular optical illusions involving a selection of photographs showcasing four thematic clusters: art production in Benin City, the traumatic sack of Benin 1897, the 1977 festival FESTAC celebrating black and African culture, and the reception of art in the Global North.

As I draw inspiration from traditional Edo architecture—such as Demas Nwoko's innovative adaption of a central courtyard[8]—these four lenticular clusters are arranged to create an intimate courtyard in which to look at the Benin artifacts. The selection of coral red for this inner space symbolizes the esteemed status of the royal monarchy and its ceremonial significance.[9] The jointly curated exhibition reframes the objects within the art history of Benin and from the perspective of their own people. Precise layout arrangements of the Benin artifacts depict how they were originally used: on ancestral shrines, as regalia and prestige objects, or as structural decoration and visual history mounted on the Oba's palace pillars.

As the visitors move around the external parts of the courtyard, they are exposed to some object biographies on selected artifacts. They reveal the provenances of the objects, while also providing an insight into the exhibition history of Benin objects in Swiss museums in the twentieth century. These outward-facing sides are painted in hues of jade blue, symbolizing water and wealth deities like Olokun,[10] associated with the kingdom's famous river trade ports [Fig. 3].

Legacy of FESTAC

A key section of the exhibition is dedicated to FESTAC,[11] a pan-African arts and culture festival that gained popular significance amid early demands for the restitution of a sixteenth century "Ivory Mask of Queen Mother Idia," looted from the Kingdom of Benin.[12] This Benin mask ultimately became the emblem for the festival and for the postcolonial liberation movements, whose claims it asserted.

In the context of modern architecture in Nigeria, FESTAC's legacy represents a pivotal moment in the elevation of arts and culture, profoundly influencing the design and purpose of contemporary cultural spaces by promoting pan-African ideals and celebrating indigenous artistic expressions, which had been marginalized during the colonial era.

Before the Nigerian civil war, my late grandfather's architecture office—Frank Mbanefo and Associates (FMAA)—won the federal competition to build one of the three venues planned for FESTAC. His winning design for Eastern Nigeria's Center of Arts and Performance left an inspiring architectural legacy that still reminds me to consciously try to appreciate and preserve cultural heritage in its rightful context [Fig. 4].

Dialogue with Benin is more than an exhibition on art, colonialism, and restitution; it's also a personal journey profoundly influenced by my early exposure to pan-African liberation movements, echoing fundamental themes that define my ongoing commitment to spatial education and cultural justice.

1 In order of the disciplines listed: Michaela Oberhofer, Esther Tisa Francini, Josephine Ebiuwa Abbe, and Solange Mbanefo
2 See Sogbesan 2022, 10–22.
3 Welton 1965.
4 Eglash 1999, 12.
5 Connah 1967, 593–609.
6 Odiase 1987.
7 Welton 1965.
8 Godwin/Hopwood 2007.
9 Onuwaje 2018, 42.
10 Ibid., 13.
11 Falola/Genova 2009.
12 Ibid., 36.

[Fig. 2] Lenticular model built by the author

[Fig. 3] Model built by the author

[Fig. 4] Original design and model for the FESTAC 1975 Arts Center

[Fig. 1] Interview with Josephine Ebiuwa Abbe

[Fig. 2] Coronation of Oba Ewuare II, the twin high priests Osa and Osuan holding his hands

Energy from the Source

Co-curating Benin Arts and Performance

In Dialogue with Benin: Art, Colonialism and Restitution is the first exhibition at the Museum Rietberg to be the result of a transcultural curatorial process. The co-curators from Nigeria and Switzerland—all women—developed the narratives and the exhibition design together. Each brought her own experience and knowledge from different disciplines such as architecture, art anthropology, provenance research, and theater arts studies to the process.[1] Josephine Abbe Ebiuwa [JEA] and Michaela Oberhofer [MO] discuss the inclusion of multiple voices as a curatorial approach and the importance of performance in Benin art [Fig. 1].

MO In a joint workshop in Benin City, we discussed the long history of the Kingdom of Benin, the trauma of 1897, and subsequent art production and the art market. But your contribution was different and new. It was about the important role of performance in Benin art. It was very moving for me when you started singing a song about the Oba of Benin and everyone in the room joined in.

JEA It is unique that African art has such a holistic nature. Apart from being a documentation of history, art as a creative expression occurs in various ceremonies. For the most part, festivals are meant to commemorate an event that has happened in the life of the people. The festival becomes a form of event where various art forms are expressed in terms of visual and performing arts, showcasing live performances such as songs, dances, and dramatic displays, like a total theater experience. For example, in terms of its aesthetic form, a mask is a sculptural piece, which is visual art, but in live performance it plays a special role, becoming part of the dancer and highlighting the costume among other elements.

MO When I look at an object like the small pendant of the Oba and his companions, I can analyze it from an aesthetic point of view. I can think about the royal guilds that made such pieces and about ivory as an exclusive material for the Oba and the palace [Fig. 2]. But what happens when you look at this pendant? What memories and emotions do you have?

JEA Yes, you just described the pendant from the perspective of an artist or an art historian. But when I look at it as an indigene and a performing artist, I see a performance, a posture in motion that signifies a performance and represents an action. I see the twin high priests Osa and Osuan holding the hands of the Oba in a performance. I am reminded of the coronation, the biggest event you can imagine in Benin [Fig. 3]. Having been fortunate to have witnessed the coronation of the current Oba, I saw the scene depicted on the pendant live as a performance. Looking at the pendant, I remember the songs of praise and Ekasa dance for the new Oba.[2] The pendant therefore evokes a lot of memories—of funeral rites and coronation ceremonies, for example—and the numerous narratives enshrined in these events and procedures, the dances and songs, and so on. So it is not just a pendant to wear, it is a recollection of significant memories.

MO For our Benin exhibition, we are trying to integrate these multiple perspectives. So tell us a little bit more about how you are bringing the aspect of performance into the exhibition.

JEA One idea is a live performance and a special choreography by myself, a drummer, and a singer that will take place in the exhibition space. The performance is filmed, and the video will be shown in the exhibition. During our workshop, the participants in Benin City liked the idea of making performance part of the exhibition. But performance is just one way to enrich the aesthetics of the exhibition.

MO Another aspect that came up in the workshop was language and the importance of Edo terms and concepts. This was also a decisive moment that changed the curatorial process. The conclusion was that Benin experts should write the exhibition texts for the Benin objects.

JEA Yes, it is about how to integrate the Benin perspective with its own particular way of writing and language of expression. Three Benin academics conversant with the aesthetics of Benin art and the contexts of usage and expression were asked to write the texts for the Benin objects in the exhibition.[3] Coming from the Indigenous people, the narratives are written from an informed and experiential perspective, not just because somebody came here and conducted interviews. The knowledge resides with the people, and the stories are based on what is taught in the culture even before some of them went to school to study the arts.

MO The African or Benin-centered perspectives on the objects and their spiritual, ceremonial, and performative dimensions enable a new approach to Benin art. But working together across borders and disciplines was also challenging. What would you say about that?

JEA I have no experience in making art exhibitions. So it was quite challenging for me having to understand the various perspectives and integrate them in order to come up with the beautiful exhibition we have today, especially for an audience in Switzerland that is not familiar with African or Benin art.

MO In what sense is a more inclusive curatorial practice important to exhibition making and to the understanding of Benin art history?

JEA Addressing the issue of decolonization is letting people tell and write their own narrative "as it is." The process of this exhibition has a dimension of collaboration and participation that is quite unique, involving workshop participation, performance, and a whole lot of expertise. Most importantly, the exhibition draws considerable energy from the source of the objects to tell their story in a more concrete, enduring, and endearing way.

INSIGNIA OF AN OBA WITH THE TWIN PRIESTS OSA AND OSUAN, EMWINEGBE Fig. 3

```
Royal Guild of Ivory Sculptors Igbesanmwan     Ivory                    Museum Rietberg, Zurich
Nigeria, Kingdom of Benin                      9.2 × 9.5 × 3.2 cm       Inv. no. RAF 606
16th/17th century                                                       Donated in 1991
```

```
- 16th/17th century: Royal Guild of Ivory Sculptors Igbesanmwan
  [...]
- 1965 (at the latest): Nigerian art dealer, exhibition Verschenkt die Schweiz Geld
  (Is Switzerland Giving Money Away?), Globus, Zurich
- 1965: Acquired by Elizabeth Zink-Niehus, Zurich
- 1991: Donated to the Museum Rietberg, Zurich
```

1 Josephine Ebiuwa Abbe is an associate professor of theater and performance studies at the University of Benin; Solange Mbanefo is an architect and activist in Switzerland. Michaela Oberhofer is an art anthropologist and curator for African and Oceanian art; Esther Tisa is a provenance historian and head of archives (both at Museum Rietberg).

2 Ekasa is a ritual dance form performed during coronations and the burial of the Queen Mother. On performances in Benin, see Abbe 2014; Abbe and Borgatti 2019.

3 Kokunre Agbontaen-Eghafona, professor of cultural anthropology at the University of Benin, is joined by Godfrey Ekhator-Obogie, historian at the University of Benin, and Patrick Oronsaye, artist, art historian, and consultant from Benin City.

[Fig. 1] Enibokun Uzébu-Imarhiagbe, Alice Hertzog, and Michaela Oberhofer with Ursula Regehr on a research visit to the exhibition *Memory: Moments of Remembering and Forgetting* at the MKB

[Fig. 2] Nigerian Delegation visiting the Benin collection in the MKB storage facility (from left to right): Anna Schmid, Chijioke McHardy Ani, Charles Uwensuyi-Edosomwan, Samson Ogiamien, Abba Isa Tijani, Patrick Oronsaye, and Kokunre Agbontaen-Eghafona

In Full View: Benin, Nigeria

Dialogue and Multi-perspectivity

In 2024, the Museum der Kulturen Basel (MKB) is launching a project series called *In Full View*, which will present projects on provenance and the future of collections. It will focus on the trajectories of the MKB's collections and develop new approaches for attributing meaning to things in collaboration with community members and academics. In 2025, the *In Full View* series revolves around the twenty-one works from Benin that are held at the MKB. It presents the findings of the collaborative provenance research of the Benin Initiative Switzerland (BIS), which established that thirteen of the artifacts were looted in 1897; two are likely to have been looted; five are unlikely to have been looted; and one was not looted.[1] In preparation, co-curators Zainabu Jallo [ZJ] and Ursula Regehr [UR] discuss the project's challenges, and how it could become an opportunity for productive exchange.

ZJ In the third installment of this new series, the looting of Benin is at the heart of our discussions. But we also want to avoid creating a frozen image of the Kingdom of Benin as a monolithic or undynamic culture. We need to convey the kingdom's development and its response to global political, social, and economic issues. The relations between institutions holding artifacts from the Benin Royal Court (and, consequently, from the Edo people of Benin) give rise to new forms of rapport, fostering enduring relationships and exchanges that transcend the unsettling historical circumstances.

UR We regard the BIS as one of these relational engagements. When Professor Kokunre Agbontaen-Eghafona visited us at the MKB, she said, "We are making history together."[2] The works from the Kingdom of Benin tell so many stories of connections, relations, and entangled histories. They also animate contemporary creative processes in Nigeria and beyond.

"Righteous rage at ancient wrongs"[3]

ZJ Yes, there are numerous perspectives beyond those of the court. In Edo state, the so-called Benin Bronzes are catalyzing a new cultural infrastructure, as exemplified by the Museum of West African Art (MOWAA) in Benin City. The focus is on transforming Benin City into a thriving center for artistic expression. The Edo state governor, Godwin Obaseki, promoted the creation of modern art within the museum grounds, not only to safeguard the ancient brass tradition but also to offer prospects for the younger generation. The idea is to foster artistic and cultural growth—one such initiative is the Nigerian Pavilion at the 2024 Venice Biennale. In 2025, the exhibition, called *Nigeria Imaginary*, will be presented in an expanded form at MOWAA. Then there are the artistic interventions of Victor Ehikhamenor and Osaze Amadasun, among others, who highlight the resilience of Benin and the lasting impact of the events of 1897. Memorable examples of previous cultural creations that centered on the history of Benin are the theater plays of Ola Rotimi—*Ovonramwen Nogbaisi* (1971) and *The Trials of Oba Ovonramwen* (1998)—which we aspire to integrate into our project.

"Those pieces are us."[4]

UR Despite the plundering of 1897, there is an enduring link between the artifacts and their original owners. When Chief Charles Uwensuyi-Edosomwan visited the collection at the MKB, he stated, "Those pieces are us." This tells us that for the Edo the works are more than museum objects; they are spiritual expressions, an integral part of their selfhood and history. They are alive and have agency.

ZJ Exactly! They are important inalienable, inviolable cultural artifacts that provide insights into the history and traditions of the Benin Kingdom. These are not merely remnants of an extinct culture: they belong to vibrant and thriving cultures with traceable lineages. As a result, descendants who know and respect the significance of their ancestral artifacts have been striving for 128 years to reclaim their cultural heritage and rightful inheritance.[5]

FESTAC '77, the Second World Black and African Festival of Arts and Culture, was an extraordinary pan-African celebration. One of the festival's most iconic symbols was a mask honoring Queen Idia, the mother of Esigie, the Oba of Benin (r. 1504–1550). The organizers hoped to have the original mask repatriated, believing it would be a defining moment of the festivities. However, much to everyone's chagrin, the custodians of the mask—the British Museum—declined to release it. This unexpected turn of events sparked a tremendous public outcry from the Black World, a "righteous rage at ancient wrongs." Even more so as these artifacts remain poignant reminders of the brutality of colonial governance.

UR The question of how we can engage with people and things in other ways—not perpetuating colonial and extractivist logics—lies at the heart of our collaboration. The BIS has es-

tablished a dialogue to build new relationships between European museums and Nigerian actors [Fig. 1]. Museums are shifting their practices and changing notions of ownership. Today, they conceive of themselves as caretakers rather than gatekeepers of collections, and makers and communities as the original owners and as sources of knowledge.[6] This shift challenges museums and their staff in many ways.

The voices of those who made the works, to whom they belong, are vital to understanding what they mean to people. Building relations of trust and mutuality, sharing knowledge, exchanging skills, and making decisions together are key to multi-perspectivity.

"We cannot talk about the future without looking at the past."[7]

ZJ Scholars and critics have raised questions about the presence of colonialism in museum provenance research and restitution projects. The allocation of work assignments, for example, replicates imperialistic world mapping. Hans Peter Hahn wonders if scrutinizing the provenance of colonial-era acquisitions does not inadvertently recreate colonial conditions.[8] This critique is worth listening to. The examination of provenance is giving rise to a new spatial pattern of research, which, to some extent, mirrors the colonial dynamics of the past.

Ethnographic museums have emerged as prominent platforms where the manifestation of structural aggression and injustice resulting from colonialism is most evident and openly acknowledged. The Benin artifacts are but a fraction of such cases in global history. Museums ought to foster intellectual growth and encourage intercultural interaction based on fairness and transparency. As Dan Hicks urges, "It is time to imagine museums as sites of conscience."[9]

UR Indeed, we have to look at the entanglements between the museums and coloniality and, in turn, their impacts on museum practices. BIS's provenance research does not solely focus on collectors, Western institutions, and archives; of paramount importance are dialogues and collaborations with Nigerian actors [Fig. 2].

1 Hertzog/Uzébu-Imarhiagbe 2023, 42–52.
2 Workshop at the MKB, Swiss Benin Forum, January 31, 2023.
3 Soyinka 2014, 189.
4 Charles Uwensuyi-Edosomwan, Chief Obasuyi of Benin, workshop at the MKB, Swiss Benin Forum, January 31, 2023.
5 See Bodenstein 2022, 226.
6 See https://re-entanglements.net.
7 Patrick Oronsaye, workshop at the MKB, Swiss Benin Forum, January 31, 2023.
8 Hahn 2023.
9 Hicks 2020a.

Fabienne Baraga

Corine Mauch

His Excellency, Baba M. Madugu

Prof. Abba Tijani

Corine Mauch
Mayor of Zurich

"The project is unique in many respects. Not only does it, for the first time, bring together eight Swiss museums in a national network, it is also the first project that, from the very beginning, was developed in close collaboration with partners in Nigeria. But the project is also important for another reason: it shines a light on a chapter of Swiss history that is well understood by experts but is only slowly gaining traction in public discourse. I am, of course, referring to Zurich's and Switzerland's manifold historical entanglements with colonialism."

His Excellency, Baba M. Madugu
Former Ambassador of Nigeria in Switzerland, Bern

"It is important to note that the ultimate aim will be to return these artifacts to their rightful owners. We know, however, that this is a process, and a long one at that. And the good news is that it is a journey which has already commenced. There is no known record that Switzerland played any role in the looting of this art, but it has voluntarily initiated this process. We must therefore express our appreciation to the Benin Initiative Switzerland and the Federal Office of Culture in building a bridge that will connect not only our two countries but also our people and continents."

Fabienne Baraga
Head of the Specialized Body for the International Transfer of Cultural Property, Swiss Federal Office of Culture, Bern

"The involvement of source communities in all stages of the provenance research, the sharing of acquired knowledge, and the joint implementation of fair and just solutions are of the utmost importance and urgency. Eight Swiss museums were able to pool their knowledge and resources in the field of provenance research. The result of this cooperation shows how valuable such a joint project can be for the research of collections and origins. In addition, this project highlights how indispensable the process of exchange and cooperation with the relevant communities of origin is."

Prof. Abba Tijani
Former Director General, National Commission of Museums and Monuments, Abuja

"Nigeria is ready to receive these objects at any time. We have the resources, we have the capability. And as we speak, we already have it in our budget to expand the existing National Museum in Benin City to give it extra storage facilities and exhibition galleries. We are planning to have the Benin Royal Museum built, and that will also house many of the collections that are going to return."

His Royal Highness Prince Aghatise Erediauwa
Royal Palace, Benin City

"In many museums, you have a religious work encased in glass. And then you see a small inscription trying to describe that object. The description is often devoid of understanding, devoid of the emotions that go with the objects. So, oftentimes when I talk about our objects, I can't help but feel extremely emotional myself. All of us feel emotional when we talk about these objects."

Dr. Annette Bhagwati
Director, Museum Rietberg, Zurich

"As long as these objects exist, new stories and new knowledge will be inscribed in them and will become part of them. And this would be my hope and my sincere and deep wish, to provide the impetus for new stories to be written. Stories of remembrance, stories of healing, stories of things explored and shared together. Stories of friendship and cooperation that will keep Nigeria, Benin, and Switzerland connected to each other and that will bring them even closer together in the future."

Dr. Carine Ayélé Durand
Director, Musée d'ethnographie de Genève

"When museums start thinking they're not owners of cultural heritage but custodians and guardians, they start realizing that there are other owners, there are traditional owners. And this was the moment when we realized that as museum practitioners we have a responsibility. There is still a place for these objects among their traditional owners – this relationship has never ended."

Charles Uwensuyi-Edosomwan, PhD
Senior Advocate of Nigeria (SAN)
Chief Obasuyi of Benin, Benin City

"It is a commendable move on the part of the Swiss people, whose good conscience in this regard has led them to engage, through their museums, in discussions over repatriations. I personally welcome these moves, which are consistent with current global thinking on looted art. It is with this in mind that I thank the Swiss people and everyone involved in this initiative for inviting us to these groundbreaking events."

Dr. Anna Schmid
Director, Museum der Kulturen, Basel

"The collections are a crucial part of the past and the history of our museums. Of course, we try to convey to visitors the different contexts that are relevant to an understanding of a particular object. But since museums are places of abstraction, we will probably only rarely succeed in conveying the emotional aspects of an object. And I think we should endeavor in future to ensure that the emotional dimension is thoroughly taken into account. We have seen how important this is in the last week."

Charles Uwensuyi-Edosomwan, PhD
Chief Obasuyi of Benin

His Royal Highness Prince
Aghatise Erediauwa

Dr. Anna Schmid

Dr. Annette Bhagwati

Dr. Carine Ayélé Durand

BIBLIOGRAPHY

Abbe, Josephine E. 2014. "Performance and Choreographic Aesthetics in Ugie-Oro Ritual Dance of the Benin People of Nigeria." PhD diss., University of Ibadan, Nigeria.

Abbe, Josephine E., and Jean Borgatti. 2019. "Ekasa: History, Image, Music and Dance." *Umewaen: Journal of Edo and Benin Studies*, 4: 1–21.

Adi, Hakim, and Marika Sherwood, eds. 2003. *Pan-African History: Political Figures from Africa and the Diaspora Since 1787*. London: Routledge.

Agbontaen-Eghafona, Kokunre. 2022. "Hintergrundgeschichte zur Restitution von Benin-Kunstwerken." In *Benin: Geraubte Geschichte*, edited by Barbara Plankensteiner, 210–221. Hamburg: MARKK Museum am Rothenbaum. Exhibition catalog.

Basu, Paul. 2011. "Object Diasporas, Resourcing Communities: Sierra Leonean Collections in the Global Museumscape." *Museum Anthropology*, 34 (1): 28–42.

Bedorf, Franziska. 2021. *Traces of History: Connecting the Kingdom of Benin with the Rautenstrauch-Joest Museum in Cologne*. Cologne: Rautenstrauch-Joest Museum.

Ben-Amos, Paula. 1983. "Introduction: History and Art in Benin." In *The Art of Power – The Power of Art: Studies in Benin Iconography*, edited by Paula Ben-Amos and Arnold Rubin, 13–16. Los Angeles: Museum of Cultural History. Exhibition catalog.

Ben-Amos, Paula. 1995. *The Art of Benin*. London: British Museum Press.

Ben-Amos Girshick, Paula. 2007. "Die Symbolik der Ahnenaltäre von Benin." In Plankensteiner 2007, 151–159.

Blackmun, Barbara Winston. 1984. "The Iconography of Carved Altar Tusks from Benin, Nigeria. (Volumes I–III) (Ivory, African Art)." PhD diss. University of California, Los Angeles. ProQuest (8411846).

Bodenstein, Felicity. 2020. "Africa: Trade, Traffic and Collections." *Journal for Art Market Studies*, 4 (1).

Bodenstein, Felicity. 2021. "Kunsthändler als Grosswildjäger: 1897–1900." In *Beute: Ein Bildatlas zu Kunstraub und Kulturerbe*, edited by Merten Lagatz, Bénédicte Savoy, and Philippa Sissis, 116–119. Berlin: Matthes & Seitz.

Bodenstein, Felicity. 2022. "Getting the Benin Bronzes Back to Nigeria: The Art Market and the Formation of National Collections and Concepts of Heritage in Benin City and Lagos." In *Contested Holdings: Museum Collections in Political, Epistemic and Artistic Processes of Return*, edited by Felicity Bodenstein, Damiana Oțoiu, and Eva-Maria Troelenberg, 220–241. New York: Berghahn.

Bradbury, R. E. 1973. *Benin Studies*, edited by Peter Morton-Williams. London: Oxford University Press.

Christie, Manson & Woods Ltd. 1978. "Important Tribal Art." Lot 267. London: Christie, Manson & Woods Ltd. Auction catalog (June 13).

Connah, Graham. 1967. "New Light on the Benin City Walls." *Journal of the Historical Society of Nigeria*, 3, no. 4 (June): 593–609.

Dejung, Christoph. 2014. "Jenseits der Exzentrik: Aussereuropäische Geschichte in der Schweiz; Einleitung zum Themenschwerpunkt." *Schweizerische Zeitschrift für Geschichte*, 64 (2): 195–209.

DMB – Deutscher Museumsbund, ed. 2021. *Leitfaden: Umgang mit Sammlungsgut aus kolonialen Kontexten*. Berlin: Deutscher Museumsbund. Digital publication.

Docherty, Paddy. 2021. *Blood and Bronze: The British Empire and the Sack of Benin*. London: Hurst Publishers.

Egharevba, Jacob. 1936. *A Short History of Benin*. Lagos: C.M.S. Bookshop.

Eglash, Ron. 1999. *African Fractals: Modern Computing and Indigenous Design*. New Brunswick, NJ: Rutgers University Press.

Eisenhofer, Stefan. 2007. "Olokun's Messengers: The Portuguese and the Kingdom of Benin." In Plankensteiner 2007, 55–64.

Eyo, Ekpo. 1977. *Two Thousand Years of Nigerian Art*. Abuja: Federal Department of Antiquities.

Falola, Toyin, and Ann Genova. 2009. "World Black and African Festival of Arts and Culture." In *Historical Dictionary of Nigeria*. Lanham, MD: Scarecrow Press.

Forman, Werner, Philipp Dark, and Bedřich Forman, eds. 1960. *Benin Art*. London: Paul Hamlyn.

Förster, Larissa, Iris Edenheiser, Sarah Fründt, and Heike Hartmann, eds. 2018. *Provenienzforschung zu ethnografischen Sammlungen der Kolonialzeit: Positionen in der aktuellen Debatte*. Munich: Museum Fünf Kontinente. Digital publication.

Geiser, Werner, ed. 1994. *Ereignis, Mythos, Deutung: 1444–1994; St. Jakob an der Birs*. Basel: Druck + Verlag Klingental.

Godwin, John, and Gillian Hopwood. 2007. *The Architecture of Demas Nwoko*. Lagos: Farafina.

Gunsch, Kathryn Wysocki. 2018. *Benin Plaques: A 16th Century Imperial Monument*. Abingdon, UK: Routledge.

Habermas, Rebekka. 2017. "Benin Bronzen im Kaiserreich – oder warum koloniale Objekte so viel Ärger machen." *Historische Anthropologie*, 25: 327–352.

Hahn, Hans Peter. 2023. "Verteile und herrsche." *Frankfurter Allgemeine*, April 18, 2023.

Harding, Leonhard. 2010. *Das Königreich Benin: Geschichte, Kultur, Wirtschaft*. Munich: Oldenbourg Wissenschaftsverlag.

Hertzog, Alice, and Enibokun Uzébu-Imarhiagbe. 2023. *Collaborative Provenance Research in Swiss Public Collections from the Kingdom of Benin*. Edited by Michaela Oberhofer and Esther Tisa Francini. Benin Initiative Switzerland. Digital Publication.

Hicks, Dan. 2020a. *British Museums: The Benin Bronzes, Colonial Violence and Cultural Restitution*. London: Pluto Press.

Hicks, Dan. 2020b. "Will Europe's Museums Rise to the Challenge of Decolonisation?" *The Guardian*, March 7, 2020.

Hicks, Dan. 2021. *The University of Oxford's Benin 1897 Collections: An Interim Report*. Oxford: Pitt Rivers Museum. Digital publication.

Hicks, Dan. 2022. "The Risks That Lurk in Europe's 'Scramble for Decolonization.'" *Hyperallergic*, July 6, 2022. Digital publication.

Hoffmann, Beatrix. 2010. "Unikat oder Dublette? Zum Bedeutungswandel musealisierter Sammlungsgegenstände aus dem Bestand des einstigen Museums für Völkerkunde Berlin." In *Die Sprache der Dinge: Kulturwissenschaftliche Perspektiven auf die materielle Kultur*, edited by Elisabeth Tietmeyer, Claudia Hirschberger, Karoline Noack, and Jane Redlin, 99–108. Münster: Waxmann.

Igbafe, Philip Aigbona. 1974. "Benin in the Pre-Colonial Era." *Tarikh*, 5: 1–16.

Igbafe, Philip Aigbona. 1975. "Slavery and Emancipation in Benin, 1897–1945." *Journal of African History*, 16 (3): 409–429.

Igbafe, Philip Aigbona. 2007. "Die Geschichte des Königreichs Benin: Ein Überblick." In Plankensteiner 2007, 41–54.

Johnston, Harry H. 1899. *A History of the Colonization of Africa by Alien Races*. Cambridge: At the University Press.

Kaehr, Roland. 2001. "Une dynastie de collectionneurs sur plus d'un siècle: Les Speyer." *Bibliothèques et Musées de la Ville de Neuchâtel*, 197: 203.

Karpinski, Peter. 1984. "A Benin Bronze Horseman at the Merseyside County Museum." *African Arts*, 17 (2): 54–62, 88–89.

Krucker, Hans. 1944. *Führer durch die st. gallische Sammlung für Völkerkunde*. St. Gallen: Tschudy.

Lagatz, Merten, Bénédicte Savoy, and Philippa Sissis, eds. 2021. *Beute: Ein Bildatlas zu Kunstraub und Kulturerbe*. Berlin: Matthes & Seitz.

Law, Robin. 1985. "Human Sacrifice in Pre-Colonial West Africa." *African Affairs*, 84 (334): 53–87.

Layiwola, Peju. 2010. *Benin 1897.com: Art and the Restitution Question; An Art Exhibition of Installations and Sculptures*. Ibadan: Wy Art Editions.

Lerch, Hansruedi. 2005. "René Gardi." Historisches Lexikon der Schweiz (HLS). Accessed Mar. 5, 2024. https://hls-dhs-dss.ch/de/articles/011814/2005-05-12/.

Leuzinger, Elsy. 1959. *Afrika: Kunst der N-völker*, Baden-Baden: Holle.

Lidchi, Henrietta. 2021. Foreword to *Provenance #2: The Benin Collections at the National Museum of World Cultures*, edited by Fanny Wonu Veys. Rotterdam: Nationaal Museum van Wereldculturen.

Lundén, Staffan. 2016. "Displaying Loot: The Benin Objects and the British Museum." PhD diss., GOTARC Series B. Gothenburg Archaeological Theses 69. Digital publication.

Luschan, Felix von. 1919. *Die Altertümer von Benin*. Berlin: Georg Reimer.

Malefakis, Alexis. 2016. "Das Schicksal der Sammlung Han Coray und das Völkerkundemuseum der Universität Zürich." In *Dada Afrika: Dialog mit dem Fremden*, edited by Ralf Burmeister, Michaela Oberhofer, and Esther Tisa Francini, 124–127. Zurich: Scheidegger & Spiess.

Müller, Daniela. 2024. *Benin Initiative Switzerland: Dialogue, Context and Mediation*. Edited by Michaela Oberhofer and Esther Tisa Francini. Digital publication, forthcoming.

Nevadomsky, Joseph. 1986. "The Benin Bronze Horseman as the Ata of Idah." *African Arts*, 19 (4): 40–47.

Nevadomsky, Joseph, and Agbonifo Osemweri. 2007. "Benin-Kunst im 20. Jahrhundert." In Plankensteiner 2007, 255–261.

Oberhofer, Michaela and Esther Tisa Francini. 2016. "Han Coray zwischen Dada und Afrika: Ein Leben für die Kunst." In *Dada Afrika: Dialog mit dem Fremden*, edited by Ralf Burmeister, Michaela Oberhofer, and Esther Tisa Francini, 114–123. Zurich: Scheidegger & Spiess.

Odiase, J. O. U. 1987. *Itan-Edo: Bini Proverbs and Their Meanings in English*. Benin City: Nationwide Publications Bureau.

Ogbebor, Enotie. 2022. "Die Zeitgenössische Kunstszene in Benin City." In *Benin: Geraubte Geschichte*, edited by Barbara Plankensteiner, 244–254. Hamburg: MARKK Museum am Rothenbaum. Exhibition catalog.

Onuwaje, Oriiz U., eds. 2018. *The Benin Monarchy: An Anthology of Benin History*. Abuja: Wells-Crimson Limited.

Oronsaye, Patrick. n.d. "The Consequences of the Benin Invasion of 1897." Digital Benin. Accessed Jan. 31, 2024. https://digitalbenin.org/oral-history?interview=1.

Phillips, Barnaby. 2021. *Loot: Britain and the Benin Bronzes*. London: Oneworld.

Pitts, Johny. 2019. *Afropean*. London: Allen Lane an imprint of Penguin Books.

Plankensteiner, Barbara, ed. 2007. *Benin – Könige und Rituale: Höfische Kunst aus Nigeria*. Ghent: Snoeck. Exhibition catalog.

Plankensteiner, Barbara. 2022. "Die Kunst und Geschichte des Königreichs Benin." In *Benin: Geraubte Geschichte*, edited by Barbara Plankensteiner, 17–62. Hamburg: MARKK Museum am Rothenbaum. Exhibition catalog.

Purtschert, Patricia, and Harald Fischer-Tiné, eds. 2015. *Colonial Switzerland: Rethinking Colonialism from the Margins*. Basingstoke, UK: Palgrave Macmillan.

Read, Charles Hercules, and Ormonde Maddock Dalton. 1899. *Antiquities from the City of Benin and from Other Parts of West Africa in the British Museum*. London: British Museum.

Rudolph Lepke's Kunst-Auctions-Haus. 1934. *Kunstsammlung Rudolf Mosse, Berlin*, Katalog 2075. Accessed May 8, 2024. https://doi.org/10.11588/diglit.5360.

Ryder, Alan Frederick Charles. 1969. *Benin and the Europeans, 1485–1897*. London: Longmans.

Sarr, Felwine, and Benedicte Savoy. 2018. *The Restitution of African Cultural Heritage: Toward a New Relational Ethics*. Paris: Ministère de la Culture. Accessed Apr. 4, 2024. http://restitutionreport2018.com/sarr_savoy_en.pdf.

Schlothauer, Andreas. 2012. "Gefunden: St. Galler Benin-Platte Ehemals Dresden." *Kunst & Kontext*, 2: 44–47.

Schroeder-Gudehus, Brigitte. 1989. "Les grandes puissances devant l'Exposition universelle de 1889." *Le Mouvement social*, 149: 15.

Schultz, Martin. 2016. "Arthur Speyer: Drei Generationen Sammler und Händler." *Kunst & Kontext: Außereuropäische Kunst & Kultur im Dialog*, 12: 5–8.

Seibert, Gerhard. 2013. "São Tomé and Principe: The First Plantation Economy in the Tropics." In *Commercial Agriculture, the Slave Trade & Slavery in Atlantic Africa*, edited by Robin Law, Suzanne Schwarz, and Silke Strickrodt, 54–78. Woodbridge, UK: James Currey.

Skowronek Tobias B., Christopher R. DeCorse, Rolf Denk et al. 2023. "German Brass for Benin Bronzes: Geochemical Analysis Insights into the Early Atlantic Trade." *PLoS ONE*, 18 (4): e0283415.

Sogbesan, Oluwatoyin Zainab. 2022. "Museums in the Era of Decolonisation: The Nigerian Perspective." *Museologica Brunensia*, 11 (1): 10–22.

Soyinka, Wole. 2014. *You Must Set Forth at Dawn: Memoirs*. Ibadan: Bookcraft.

Steffan, Roland. 1989. *Sammlung für Völkerkunde*. Braunschweig: Westermann.

VMS – Verband der Museen der Schweiz. 2022. *Provenienzforschung im Museum II: Sammlungen aus kolonialen Kontexten; Grundlagen und Einführung in die Praxis*. Zurich: Verband der Museen Schweiz. Digital publication.

Webster, W. D. 1899. "Catalogue, No. 19." In *Illustrated Catalogue of Ethnological Specimens, European and Eastern Arms and Armour, Prehistoric and Other Curiosities*. Vol. 3, Nos. 18 to 23. Bicester, UK: W. D. Webster.

Welton, Michael Robert. 1965. *Belief and Ritual in Edo Traditional Religion*. Vancouver: University of British Columbia.

Zian, Yasmina, and Marie-Sophie de Clippele, eds. 2021. *Rapport sur l'avenir des collections extra-européennes conservées en fédération Wallonie-Bruxelles*. Brussels: Académie royale de Belgique. Digital publication.

ONLINE SOURCES

Africa Art Archive (website). Museum Rietberg Zürich and Universität Zürich. Accessed Mar. 28, 2024. https://africa-art-archive.ch/en/.

British Museum. "Benin Bronzes." Accessed Apr. 4, 2024. https://www.britishmuseum.org/about-us/british-museum-story/contested-objects-collection/benin-bronzes.

[Re:]Entanglements (website). Arts & Humanities Research Council. Accessed Feb. 2, 2024. https://re-entanglements.net.

Digital Benin (website). Accessed May 18, 2024. https://digitalbenin.org.

"Digital Benin brings together all objects, historical photographs and rich documentation material from collections worldwide to provide a long-requested overview of the royal artefacts from Benin Kingdom looted in the late nineteenth century. The historic Benin objects are an expression of Benin arts, culture and history, and were originally used as royal representational arts, to depict historical events, to communicate, to worship and perform rituals." It currently lists seventy objects from seven of the BIS museums.

AUTHORS

Josephine Ebiuwa Abbe
is an associate professor in the Theatre Arts Department at the University of Benin, Nigeria. She holds a PhD in performance studies (African dance) and is a dancer, singer, and choreographer with experience and expertise in both the theory and practice of African dance studies and performance.

Samuel B. Bachmann
is currently completing his PhD at the Center for African Studies at the University of Basel on "The Emergence of Scientific Collections on Africa in Swiss Ethnographic Museums from 1890: Knowledge and Ignorance of the Museum as a Colonial Archive." Since 2017, he has been curator of the Africa collections at Bernisches Historisches Museum.

Julien Glauser
is a social anthropologist, museologist, and urban planner. He is curator at the Musée d'ethnographie de Neuchâtel, where he oversees the sub-Saharan Africa and East Asia collections. He is also active as an independent researcher and consultant, developing a wide range of skills in the fields of social science, museology, and "skate urbanism."

Maylawi Herbas
has been a provenance researcher at the Museum Schloss Burgdorf since 2023 and is currently working on her PhD at the University of Basel on "The Person behind the Mummy: Interdisciplinary Provenance Research, Biomedical Aspects, and Mummy Stories in Swiss Museums and Collections."

Alice Hertzog
is a social anthropologist and provenance researcher at the Völkerkundemuseum der Universität Zürich. She researched and co-authored the BIS report (2022) and co-curated the exhibition *Benin Dues: Dealing with Looted Royal Treasures* (2024) at the Völkerkundemuseum. She is an alumna of Cambridge University, École normale supérieure, Sciences Po, and ETH Zurich.

Zainabu Jallo
is a postdoctoral researcher and lecturer in anthropology at the universities of Basel and Bern in Switzerland. Her research interests include criminal anthropology with a special focus on material culture, museum anthropology, and Afro-Atlantic diasporas.

Yann Laville
is an anthropologist, head of the exhibition department at the Musée d'ethnographie de Neuchâtel, and a lecturer in ethnomusicology at the Institut d'ethnologie de l'Université de Neuchâtel, where he created the master's degree in ethnomusicology in partnership with the Haute école de musique in Geneva.

Alexis Malefakis
holds a PhD in social anthropology from the University of Konstanz (Germany). He is the curator for the Africa collections at the Völkerkundemuseum der Universität Zürich, where he also lectures on anthropology. Together with Alice Hertzog, he curated the exhibition *Benin Dues: Dealing with Looted Royal Treasures* (2024).

Solange Mbanefo
holds an MSc in Architecture from the Accademia di Architettura di Mendrisio, Switzerland, and a postgraduate diploma in Building Information Management from the Dublin Institut of Design in Ireland. She held scientific research positions at the University of Basel and ETH Zurich, Switzerland, and co-founded Matri-Archi(tecture), an interdisciplinary association dedicated to African spatial education. She is guest co-curator and designer for the Benin exhibition at the Museum Rietberg (2024).

Floriane Morin
is an art historian and curator at the Musée d'ethnographie de Genève, responsible for the Africa collections. She specializes in provenance research and is curator of the MEG's temporary exhibition *Remembering: Geneva in the Colonial World* (May 3, 2024 – January 5, 2025).

Daniela Müller
is a historian and provenance researcher at the Museum der Kulturen Basel, where she is currently researching the institution's Egyptian collections. She has previously conducted provenance and historical research for the BIS at the Museum Rietberg in Zurich and is author of the second BIS report (2024).

Michaela Oberhofer
has curated the Museum Rietberg's Africa and Oceania collections since 2014. She is also deputy head of curatorship and shares responsibility for the Benin Initiative Switzerland (2021–2024) and the Himmelheber Archive (2019–2025). In her curatorial and scholarly practice, she attaches great importance to dialogue and exchange with partners from Africa and the diaspora.

Samson Ogiamien
is a member of the noble Ogiamien family, in Benin City, Nigeria. He has been working as an artist in Graz, Austria, for several years. His art deals with the structures of memory and often demonstrates the traditional function and importance of the bronze cast.

Patrick Oronsaye
is an art historian and expert in Benin cultural heritage. He is a member of the royal family and the great-grandson of Oba Ovonramwen. He previously worked for the National Commission for Museums and Monuments in Benin City and was part of the museum's curatorial team. Currently, he runs an orphanage founded by his mother, Princess Catherine Aiyemekpen Oronsaye.

Ursula Regehr
is a social anthropologist and has been curator of the Africa collections at Museum der Kulturen Basel since 2021. She is interested in the multiplicity of forms of being in the world, storytelling, and art. In 2023, she curated *Alive: More Than Human Worlds*.

Anja Soldat
became curator of ethnology at the Kulturmuseum St. Gallen in 2022 and is writing a PhD on "Power, Wealth, and Beauty: On the Trail of a Museum Object in Switzerland and Côte d'Ivoire." She has made several research trips to the Côte d'Ivoire as part of the doctoral program.

Esther Tisa Francini
is a historian and has responsibility for the archive and provenance research departments at the Museum Rietberg. She is interested in the history of the art market, of collecting, and of museums as well as in the issues surrounding looted art. She is joint project lead of the Benin Initiative Switzerland and co-curator of the exhibition *In Dialogue with Benin: Art, Colonialism and Restitution* (2024).

Lucky Igohosa Ugbudian
lectures in the Department of History and Strategic Studies at Alex Ekwueme Federal University Ndufu-Alike, Nigeria. He is currently a fellow at the Institute of History, University of Bern, working on the initiatives for the restitution of Benin artifacts in Switzerland. He obtained his PhD from the Department of History and International Studies at the University of Uyo. In 2021, he worked on the Benin artifacts at the Rautenstrauch-Joest Museum in Cologne, Germany.

Enibokun Uzébu-Imarhiagbe
is a historian at the University of Benin in Nigeria, specializing in legal history and the role of women in Nigerian law. Acting for the BIS, she has focused on provenance research, oral history, and historiography in Nigeria and organized the workshop at the University of Benin in March 2022 on research and dialogue relating to the Benin collection in Swiss Museums.

IMAGE RIGHTS AND CREDITS

pp. 1/3 top/18 center right/26 top and bottom: Photo: Alice Hertzog
p. 2: © The Trustees of the British Museum, London, Archive, AF-A179-17
p. 4: © VMZ, photo: Kathrin Leuenberger
p. 5: Map: Sandra Doeller
pp. 5/20 bottom left and right © MRZ, photo: Matthias Willi
p. 10: Pitt Rivers Museum, University of Oxford, 1998.208.15.11
p. 11: Kunsthaus Zürich, library, N0005_168_197_18A, photo: Walter Dräyer
p. 12: ProLitteris/2024
p. 13: © MRZ, film still: Adeoluwa Owu
pp. 14/19/20 top left/39/51/52 top/108 © MKB, Omar Lemke, 2022
pp. 17/35/38 bottom/79/80 top/81 center/103 center/107: MRZ, photo: Rainer Wolfsberger
p. 18: Photo: unknown; bottom right: Film still: Adeoluwa Owu
p. 21: Photo: unknown
p. 26 center: © MRZ, film still: Melanie Gärtner
pp. 29 top/67–69/88/91 top: © MEG, photo: Jonathan Watts
p. 29 bottom right: MRZ, archive, p. 0002–0005
p. 30: Map drawn by Sandra Doeller (content by Alice Hertzog and Daniela Müller)
p. 32: © MRZ, photo: Masus Meier
pp. 38/71/72 top: © MEN, photo: Alain Germond
p. 40: © VMZ, photo: Owu Adeoluwa Emmanuel
p. 43 above: The Trustees of the British Museum, London, Archive, Af,A79.13, photo: Reginald Granville; bottom: © VMZ, Raffael Thielmann
pp. 44/47: Film stills: Tillo Spreng
pp. 47 bottom right/112/116: Film stills: Walter Fuchs
p. 52, fig. 2: National Museum of African Art, Smithsonian Institution, Eliot Elisofon Photographic Archives: cabinet card EEPA 1993-014, photo: Cyril Punch
p. 53: Collection records, MKB; Photographic Archive Museum der Kulturen Basel, X 255 and X 3936
pp. 55/56: © BHM, photo: Christine Moor
p. 57: © BHM, Ethnographic Collection Archive, A.001.009.004; fig. 4: Världskulturmuseerna Stockholm, 1907.44.0380; fig. 5: Collection Wereldmuseum Coll.nr. RV-1310-5

pp. 59/60 top/61, fig. 3: © KMSG, photo: Michael Elser
p. 60, fig. 4: The Trustees of the British Museum, London, Archive, Af,B110.1.a-b
p. 61: figs. 5/6: © KMSG, photo: Anja Soldat
pp. 63/64: © VMZ, photo: Kathrin Leuenberger
p. 65, fig. 4: Kunsthaus Zürich, library, P0151_60, photo: Walter Dräyer
p. 65, fig. 5: VMZ, Archive Han Coray S/I/004/06, photo: G. R. Farley-Photography, Utica
p. 73: Vienna City Hall Library, D-76617/1912
pp. 75/76/77: © MSB, photo: Mauricio Pinheiro
p. 76: Photo: unknown
p. 80: The Trustees of the British Museum, London, Archive, Af,A154.1
p. 81 bottom: Genthe, Leipzig, private property of the Heinrich family
pp. 84/87 top: Prune Simon-Vermot/MEN, 2024
p. 87 center and bottom: Osaze Amadasun/MEN, 2024
p. 91 bottom: © MEG, photo: Samson Ogiamien, 2023
p. 93: © BHM, photo: Christine Moor
p. 95: © BHM, photo: Marina Berazategui
pp. 89/99 top: © VMZ, photo: Alice Hertzog
p. 99: © VMZ, Klaus Powroznik
p. 103 top: Photo: Solange Mbanefo; bottom: Courtesy of the Frank Mbanefo and Associates Architecture (FMAA) Foundation, Enugu, Nigeria
p. 104 top: Photo: Masus Meier
pp. 104 bottom/120: Photo: Omoregie Osakpolor

COLOPHON

Edited by:
Esther Tisa Francini, Alice Hertzog, Alexis Malefakis, Michaela Oberhofer

With contributions by:
Samuel B. Bachmann, Josephine Ebiuwa Abbe, Julien Glauser, Maylawi Herbas, Alice Hertzog, Lucky Igohosa Ugbudian, Zainabu Jallo, Yann Laville, Alexis Malefakis, Solange Mbanefo, Floriane Morin, Michaela Oberhofer, Samson Ogiamien, Patrick Oronsaye, Ursula Regehr, Anja Soldat, Esther Tisa Francini, Enibokun Uzébu-Imarhiagbe

Coordination:
Mark Welzel

Translations into English:
Tradukas GbR (Melanie Newton, Lucy Powell, Mark Willard), Susanna Day Hamnett

Copy editing and proofreading:
Tradukas GbR (Simon Cowper)

Design:
Bureau Sandra Doeller (Sandra Doeller, Merle Petsch, Benedikt Munzert), Frankfurt am Main

Image processing, printing, and binding:
DZA Druckerei zu Altenburg GmbH, Thuringia

© 2024 Museum Rietberg, Völkerkundemuseum der Universität Zürich, and Verlag Scheidegger & Spiess AG, Zurich

© for the texts: the authors
© for the images: see the image rights and credits

Despite our best efforts, we have not been able to identify the holders of copyright and printing rights for all the illustrations. Copyright holders not mentioned in the credits are asked to substantiate their claims, and recompense will be made according to standard practice.

Museum Rietberg
Gablerstrasse 15
8002 Zurich
Switzerland
www.rietberg.ch

Universität Zürich
Völkerkundemuseum
Pelikanstrasse 40
8001 Zurich
Switzerland
www.musethno.uzh.ch

Verlag Scheidegger & Spiess
Niederdorfstrasse 54
8001 Zurich
Switzerland
www.scheidegger-spiess.ch

Scheidegger & Spiess is being supported by the Federal Office of Culture with a general subsidy for the years 2021–2024.

All rights reserved; no part of this publication may be reproduced, stored in a retrieval system, or transmitted in any form or by any means, electronic, mechanical, photocopying, recording, or otherwise, without the prior written consent of the publisher.

ISBN 978-3-03942-198-5

German edition:
ISBN 978-3-03942-197-8

Photo by Omoregie Osakpolor of the National Museum, Benin City, 2024